QUEEN MARY'S DOLLS' HOUSE

OFFICIAL GUIDEBOOK

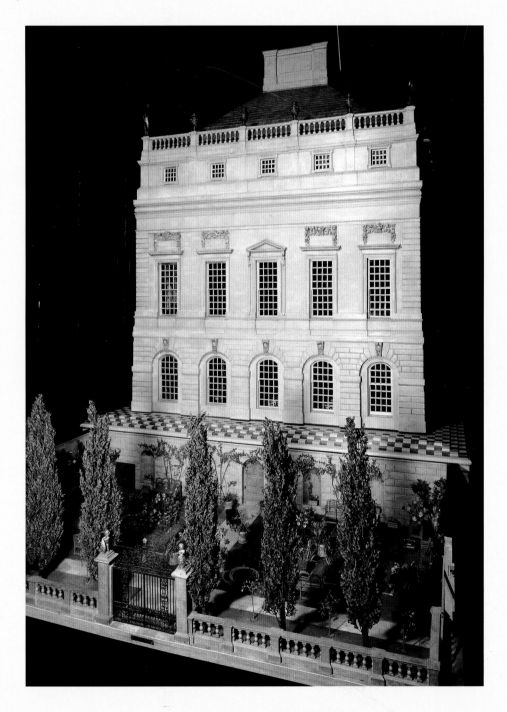

ROYAL COLLECTION PUBLICATIONS

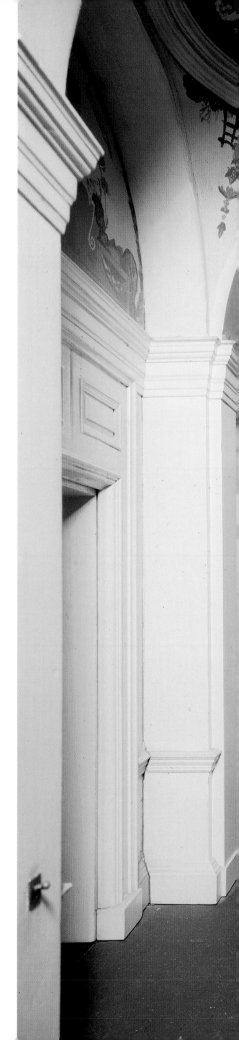

Published by
Royal Collection Enterprises Ltd
St James's Palace, London SW1A 1JR

For a complete catalogue of current publications, please write to the address above, or visit our website on www.royalcollection.org.uk

First published by Royal Collection Publications in 2002.
This edition revised 2004, reprinted 2006, 2009
© 2009 Royal Collection Enterprises Ltd.
Text by John Martin Robinson and reproductions of all items in the Royal Collection
© 2009 HM Queen Elizabeth II.

010229/09

ISBN 978 1 902163 437
British Library Cataloguing in Publication Data:
A catalogue record for this book is available from the British Library.

Designed by Baseline Arts Ltd, Oxford
Produced by Debbie Wayment
Printed and bound by Norwich Colour Print Ltd

For ticket and booking information, please contact:
Ticket Sales and Information Office
Buckingham Palace
London SW1A 1AA
Booking line: +44 (0) 20 7766 7300
Group bookings: +44 (0) 20 7766 7321
Fax: +44 (0) 20 7930 9625

Email: bookinginfo@royalcollection.org.uk
 groupbookings@royalcollection.org.uk
 www.royalcollection.org.uk

Mixed Sources
Product group from well-managed
forests and other controlled sources
www.fsc.org Cert no. TT-COC-002425
© 1996 Forest Stewardship Council

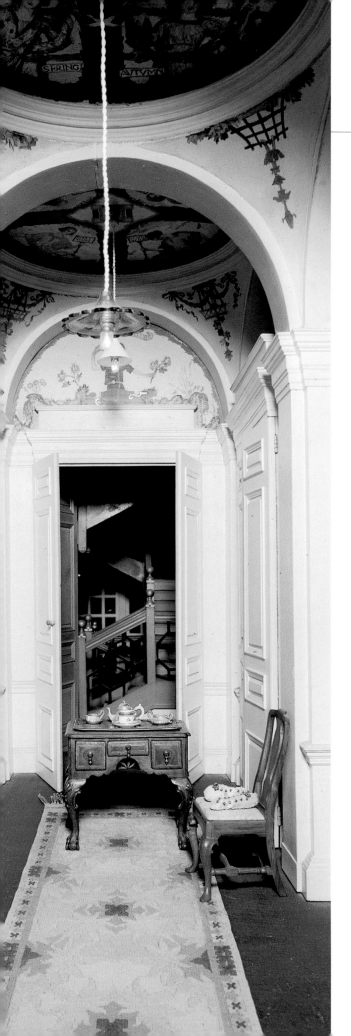

CONTENTS

Introduction 5

 Princess Marie Louise 8

 Sir Edwin Lutyens 9

 The Dolls' House Committee 11

 The Creation of the Library 17

Queen Mary's Dolls' House – An Illustrated Tour

 The Exterior 25

 The Ground Floor

 The Entrance Hall 29

 The Dining Room 31

 The Service Rooms 34

 The Library 38

 The First Floor

 The Upper Hall 41

 The Saloon 42

 The Royal Bedrooms 45

 The Queen's Apartment 45

 The King's Apartment 48

 The Mezzanine and Top Floor

 The Princess Royal's Bedroom 53

 The Queen's Sitting Room 55

 The Night Nursery 56

 The Day Nursery 57

 The Linen Room 58

 The Housekeeper's Bedroom 58

 The Housemaid's Closet 58

 The Wine Cellar 60

 The Garage 62

 The Garden 63

LEFT: The Queen's Wardrobe on the first floor of Queen Mary's Dolls' House.

FRONTISPIECE: The dolls' house, with the outer case lowered.

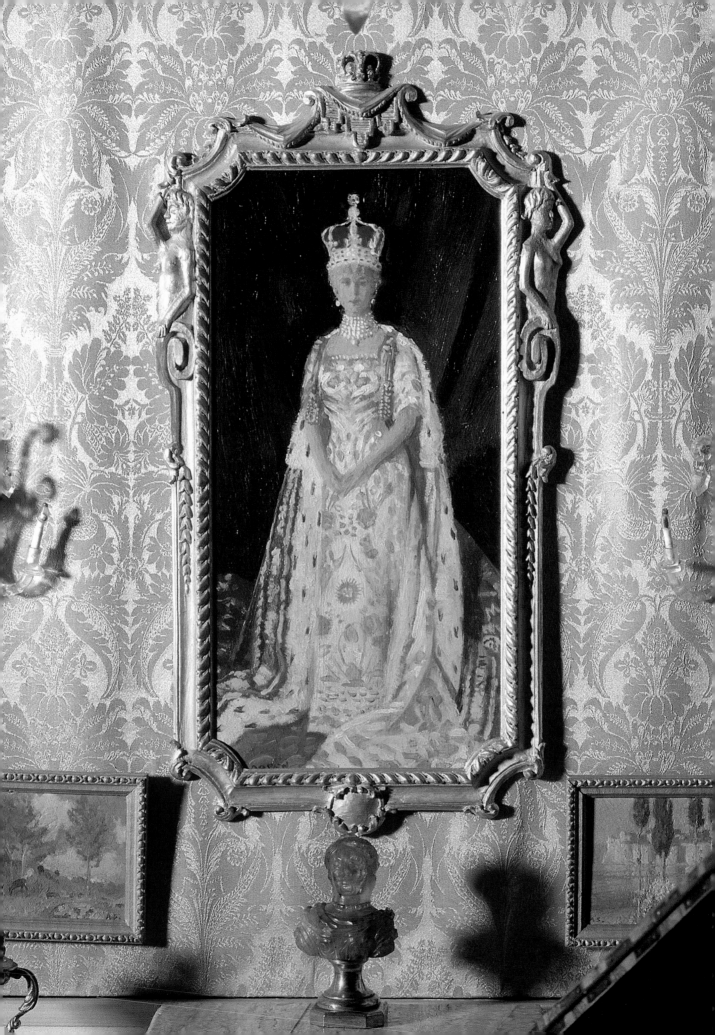

INTRODUCTION

The Wisden cricket bat from the games cupboard off the Hall, set against a full-size cricket ball to give an idea of scale. The house has a full set of classic English games equipment.

A pair of Purdey shotguns and their miniature cartridges against a real cartridge to give scale. King George V was so pleased with these guns that he asked for them to be displayed on top of one of the folio cabinets in the Library, rather than placed out of sight in the gun cupboard.

RIGHT: The top of one of the folio cabinets in the Library, with an array of miniature objects including cigars, matches and a pipe for the smoker, a statue of Napoleon in characteristic pose, and the two Purdey guns.

LEFT: State portrait of Queen Mary by Sir William Orpen in the Saloon. The lid of the grand piano is on the right.

QUEEN MARY'S DOLLS' HOUSE is not a dolls' house in the usual sense of the words – that is, as a children's toy. It is instead a glorified and fully furnished architectural model, created by the great British architect Sir Edwin Lutyens, and intended to be an historical record of the ideal early twentieth-century English house. It is also meant to be a source of fun, even a light-hearted joke. Conceived in 1921, it was a product of the period just after the First World War when, in reaction to the horrors of the recent past, people wished to escape into a brighter, more frivolous world and enjoy themselves. The 1920s was the decade of the 'bright young things' and the dolls' house reflects some of that lack of solemnity and lightness of spirit.

It is a peculiarly English conceit, being a national monument in the form of a miniature building. It had a serious purpose as a demonstration of the best of English arts, crafts and manufacturing as they affected contemporary domestic life. The house was originally a star exhibit at the British Empire Exhibition at Wembley in 1924, the first great post-war international trading exhibition, planned as an advertisement and celebration of the economic products of Britain and her colonies. It was intended to promote international trade and economic growth after the disruption of the war. Many of the components of the dolls' house are miniature versions of goods from classic British manufacturers of the day, from Wisden cricket bats and Waring & Gillow furniture to Purdey guns, Rolls-Royce motor cars and even Cooper's Oxford marmalade and Rowntree's sweets. A surprising number of these famous names are still in business today (albeit under different ownership), over eighty years later, though others have already passed into history.

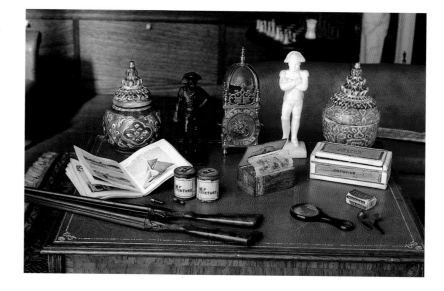

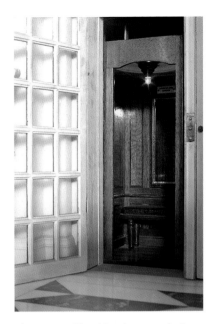

The passenger lift, with mahogany and mirror interior. The house contains two electric lifts – the other is for luggage – both made by Otis and capable of working. The lift cables are made of fine fishing line.

King George V and Queen Mary in Coronation Robes, 22 June 1911. Queen Mary was well known for her interest in furniture and the decorative arts, and the dolls' house was conceived as a demonstration of British craftsmanship and manufacturing skill as well as a tribute to the royal family after the First World War.

The house had another long-term purpose, in that it was intended as an accurate record of a house of its time. As Lutyens described it:

> *Let us devise and design for all time something which will enable future generations to see how a king and queen of England lived in the twentieth century, and what authors, artists and craftsmen of note there were during their reign.*

The aim was to present a little model house of the early twentieth century, fitted up with perfect fidelity down to the smallest details, such as kitchen provisions or even lavatory paper in the bathrooms. It was intended to represent a genuine and complete example of a domestic interior with household arrangements characteristic of contemporary life, in order to provide an interesting record for the future. In the words of the writer A. C. Benson (1862–1925), who edited the official two-volume history of the house, published in 1924:

> *if we suppose that the present Queen's House lasts on for, say, two hundred years, the little mansion which seems positively the last word in convenience and beauty … our successors will look at [it] in astonishment, and wonder that men could ever have deigned to live in so laborious and cumbrous a way … But at the same time, how they will value the House as an historical document.*

Now that it is well on the way to becoming a hundred years old, this is perhaps the principal interest of the house – as an untouched example of the taste in interior decoration and fitting-up of a rich house of that period. However, it was already something of an anachronism when it was built. Although its promoters in 1921–4 spoke of it as a model and record of a contemporary house, it is really an Edwardian or pre-war house. Lutyens and his architectural contemporaries such as Guy Dawber, Herbert Baker, Detmar Blow and Reginald Blomfield would have had few chances to build a real house like this in the changed economic circumstances after the First World War. This gives Queen Mary's Dolls' House a particular poignancy as an architectural record.

Primarily, however, the dolls' house was conceived as a national tribute to the royal family, in the form of a gift to Queen Mary, as a sign of the affection in which she and her husband King George V were held, and in acknowledgement of their steadfast leadership during the war. Everything in the house was a present, whether from the artists, craftsmen and manufacturers who made its contents, or in the form of small individual donations to pay for particular aspects of the work. Queen Mary herself, when she wrote in 1924 to thank all those who had been involved, described it as 'the most perfect present that anyone could receive'.

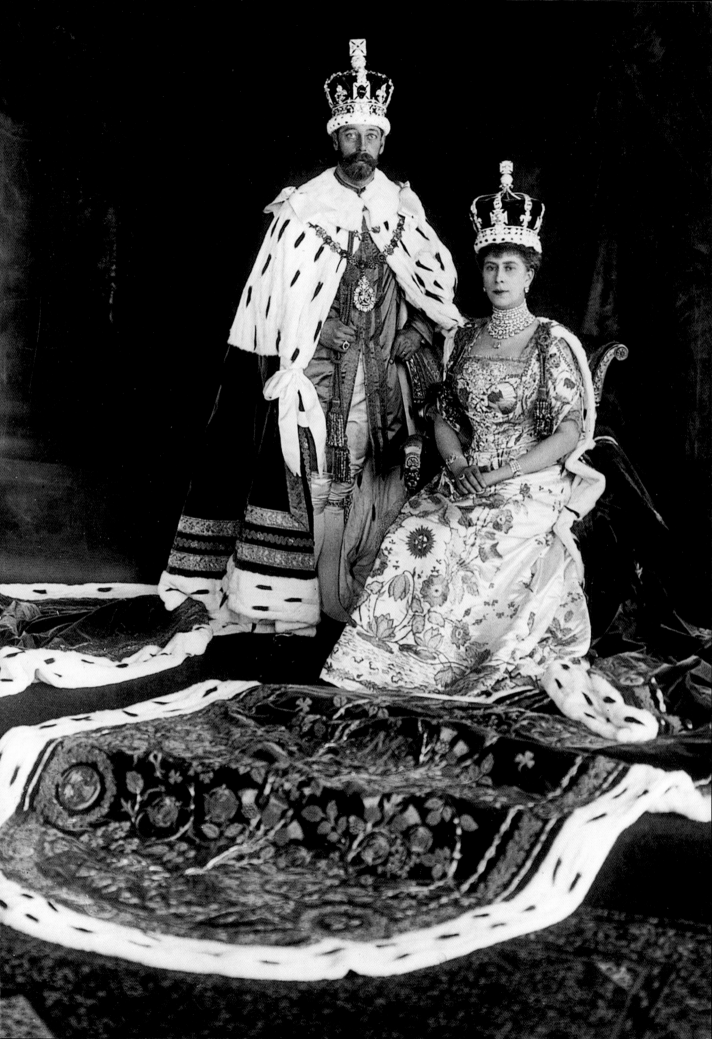

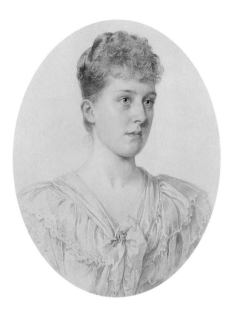

Josephine Swoboda, *Princess Marie Louise of Schleswig-Holstein*, 1891. Princess Marie Louise was a granddaughter of Queen Victoria and first cousin of King George V. The dolls' house was her idea, and owed much of its success to her persuasive organisational skills and friendships in artistic and literary circles.

Princess Marie Louise

The house was the brainchild of Princess Marie Louise (1872–1956), a first cousin of King George V and the youngest daughter of Queen Victoria's fifth child, Princess Helena, and Prince Christian of Schleswig-Holstein. Marie Louise had been a childhood friend of Queen Mary and was a great favourite of King George V. Her marriage to a prince of Anhalt had ended in annulment, and by the 1920s she was living with her family at Cumberland Lodge in Windsor Great Park, a grace-and-favour residence. Marie Louise was interested in books, music and the arts, and her personal circle of friends was drawn from that milieu.

At Easter in 1921, when the Court was at Windsor (a tradition going back to the Middle Ages when the feast of St George, the national saint, and the ceremonies of the Order of the Garter were celebrated in April of each year), Princess Marie Louise had spent the day with the King and Queen at the castle where they had shown her much kindness. When she returned home to Cumberland Lodge she found her mother and sister assembling a collection of miniature furniture for Queen Mary. The Queen's greatest enthusiasm was for old furniture and interior decoration, and she was an avid collector of 'antiques'. Queen Mary had a particular passion for miniature objects: Fabergé animals, oriental hardstone carvings, children's silver furniture, eighteenth-century cabinet-makers' apprenticeship models and similar examples of 'tiny craft', which she displayed in specially made glass cabinets in the private rooms of the royal palaces. This gave Princess Marie Louise an idea. She announced to her family that she would commission a dolls' house as a present for the Queen.

The idea could have been no more than an eccentric whimsy, but because of Marie Louise's friendships in literary and artistic circles she was able to involve a number of eminent figures in the project, and in particular the greatest architect of the age, Sir Edwin Lutyens. It was Lutyens' genius which transformed the project and made it into the extraordinary work of art that was eventually achieved. At the Royal Academy Summer Exhibition that year Princess Marie Louise approached Lutyens and asked him if he would do her a favour. Slightly intrigued, Lutyens asked what it was. She replied, to design a dolls' house for Queen Mary. Other architects of his stature, or indeed those of lesser ability but with a degree more pompous self-regard, might have reacted differently. Lutyens, however, was enthusiastic and agreed immediately.

Lutyens himself had an element of the child about him, and a particular streak of playfulness in his artistic make-up. His own engagement present to his future wife, Lady Emily Lytton, in 1896 had been an elaborate casket containing, among other things, the miniature plans for their ideal home. At the Liverpool Catholic Cathedral (his never-completed final masterpiece), he designed the

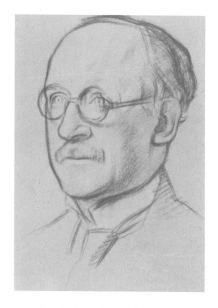

Sir William Rothenstein, *Sir Edwin Lutyens*. This portrait of the architect is one of several hundred miniature works of art commissioned for the house. Lutyens was the greatest British architect of the first half of the twentieth century, and his genius transformed the dolls' house project from a whimsical curiosity to a work of art. Frank Lloyd Wright (1857–1969), the famous American architect and contemporary of Lutyens, voiced 'admiration for the love, loyalty and art with which this cultured architect, in love with Architecture, shaped his buildings. To him the English chimney, the gable, the gatepost, monumentalised in good brickwork and cut-stone, were motifs to be dramatised with great skill. He was able to idealise them with a success unequalled. Nor can I think of anyone able to so characteristically and quietly dramatise the old English feeling for dignity and comfort in an interior, however or wherever that interior might be in England.' A notable tribute from one of America's most important twentieth-century architects to the designer of the dolls' house.

banisters of the stairs down to the crypt to make it easy for choir boys to slide down them. At Little Thakeham in Sussex (built 1902), one of his finest country houses, he provided a window on the nursery floor so that nanny and the children could peep at the 'grown-ups' down below. The idea of designing a dolls' house would have appealed to his playful, child-like streak.

It would also have tickled his sense of humour. As part of his greatest scheme, the capital of India at New Delhi, begun in 1912, Lutyens was working contemporaneously on the palatial Viceroy's House. This was the largest house of the time. It would have amused Lutyens to have received a commission for the smallest, too. He had a very pronounced, if sometimes startling, sense of humour: genial, whimsical, disconcerting, irreverent and facetious. When a very grand lady, apropos of some international crisis, said she was an ostrich and buried her head in the sand, he replied 'Oh, and do you have very beautiful tail feathers?' And when Montagu Norman, the governor of the Bank of England, showed Lutyens into the hallowed Court Room (where the financial destiny of the world had been controlled for two centuries) he broke into a two-step and exclaimed 'Just the place for a *thé dansant*.' (He did not subsequently receive the commission to reconstruct the Bank of England.)

Sir Edwin Lutyens

Sir Edwin Lutyens (he was knighted in 1918) was the architect *par excellence* of the era of King George V, responsible for public memorials to the First World War, notably the Cenotaph in Whitehall and the great Arch at Thiepval on the Somme, prestigious buildings in the City of London and the British Embassy in Washington as well as New Delhi. He had originally established his name as a designer of houses in Surrey in the 1890s and early 1900s, following in the steps of Philip Webb, Norman Shaw, and his old master (in whose office he had trained), Sir Ernest George (1839–1922). His work 'knew many phases', and during the Edwardian period it developed from his earlier Surrey Arts and Crafts manner to a refined and original classicism, inspired by the English seventeenth century and the work of Inigo Jones and Sir Christopher Wren, and the masters of the High Renaissance in Rome – Bramante, Sangallo, Peruzzi and Michelangelo. The dolls' house is a product of this later mood, with many resonances from the work of Lutyens' architectural heroes.

Lutyens, born in 1869, was the eleventh of fourteen children of Captain Charles Henry Augustus Lutyens, an officer in the Lancashire Fusiliers. Originally merchants from the Baltic who had settled in England in the early eighteenth century, the Lutyenses had developed a strong military tradition with service in North America and during the Napoleonic Wars. The family also had an artistic

Sir William Nicholson, *Gertrude Jekyll*, 1920. The famous garden designer was an old friend and supporter of Lutyens and was responsible for the garden of the dolls' house, which pulls out of a drawer in its base.

streak. After retiring from the army, Lutyens' father had made a reputation for himself as a painter of fox-hunting subjects and landscapes, and divided his time between London and Surrey, acquiring a country retreat at Thursley near Godalming. Family friends included well-known artists such as the children's illustrator Randolph Caldecott (1846–86), who taught Lutyens to sketch old vernacular buildings; and Sir Edwin Landseer (1802–73), one of Queen Victoria's favourite artists, after whom Lutyens was named. A delicate child (known as Ned to his family), he was not sent away to boarding school but educated mainly at home and in London day schools. It was not surprising, therefore, that Lutyens followed his artistic bent. He later told the writer Osbert Sitwell (who claimed to have been educated 'during the holidays from Eton'): 'Any talent I may have had was due to long illness as a boy, which afforded me time to think, and to subsequent ill-health, because I was not allowed to play games, and so had to teach myself, for my enjoyment, to use my eyes instead of my feet.' Architecture was the perfect field for Lutyens' particular talents for mathematics, drawing and observation, combined with an extraordinary visual memory, inherited traits which in his case were combined with a 'creative imagination of genius'.

After studying architecture for two years at the South Kensington Schools (later the Royal College of Art) where the fashionable Arts and Crafts architect and protégé of Ruskin's, Detmar Blow (1867–1939), was a contemporary, Lutyens obtained a place in the 'Eton of Offices', that of the architects George and Peto. However, he stayed there for only a year before precociously setting up in independent practice, aged twenty, in 1889. He benefited from the encourage- ment of his Surrey neighbours, especially the famous gardener Miss Gertrude Jekyll, for whom he designed Munstead Wood, her house near Godalming. Jekyll's horticultural innovations revolutionised the English approach to gardening and were a key factor in the twentieth-century revival of gardening in the British Isles. Miss Jekyll, who was memorably described by the writer Logan Pearsall Smith as looking like 'some ancient incredibly aristocratic denizen of a river jungle, gazing gravely out from the tangled reeds,' was a great influence on the young Lutyens, and worked frequently with him on the design of the gardens which formed an integral aspect of his new houses. She was to design the garden for the dolls' house almost as a matter of course.

Lutyens became widely accepted in his own lifetime as one of the greatest, if not *the* greatest English architect. Christopher Hussey, in his biography of the architect, wrote:

The genius of Lutyens was a legend that dawned on the early Edwardians, had become a portent before the First World War, and remained a fixed star in the

The Garden by Gertrude Jekyll, one of the miniature volumes from the dolls' house Library, photographed on a classic Lutyens bench in the garden. As well as designing the garden itself, Miss Jekyll also contributed a copy of her great work on garden design to the leather-bound miniature volumes in the Library.

architectural firmament, despite the rising of the constellation of Le Corbusier, until his death on New Years' Day 1944....In his lifetime he was widely held to be our greatest architect since Wren if not, as many maintained, his superior.

Lutyens' buildings

exceeded in quantity any noted designer in these or other days and by their variety and distinction almost defy classification … He had his amazing capacity to project his imagination into every space of whatever he was building, so that he lived the life of the people who would ultimately inhabit it, more vividly perhaps than they ever would themselves and in a sense became *the building.*

This ability to project himself into his designs stood Lutyens in good stead when presented with a miniature but perfect architectural exercise such as the dolls' house.

This was the genius whom Princess Marie Louise had the good fortune to engage from the start. Lutyens transformed a miniature curiosity into a serious, albeit irreverent, architectural venture.

The Dolls' House Committee

The project was blessed with other good luck during its incubation, notably its incorporation into the programme for an Empire trade exhibition of arts and manufacturing in the nineteenth-century tradition – a tradition initiated by the Great Exhibition of 1851, which had been the brainchild of Prince Albert, Queen Victoria's Consort. At his first meeting with Princess Marie Louise after the Royal Academy Summer Exhibition, Lutyens brought with him Sir Herbert Morgan who was President of the Society of Industrial Artists, one of the bodies involved in the Government's project for the British Empire Exhibition at Wembley Park, Middlesex, planned for 1924.

Morgan immediately saw the value of the dolls' house as a miniature display of British craftsmanship and a potentially popular public exhibit in an intended 'gallery of the arts'. The exhibition was based on a postponed, pre-war idea of the Anglo-Canadian shipping magnate, Lord Strathcona, for a showcase of the enterprise of the British Empire. The creation of the proposed dolls' house fitted perfectly into the revised timetable for this exhibition and gave a deadline and purpose to work towards. The first stage was to establish a wider committee to mastermind the project. Sir Herbert Morgan agreed to host a dinner party at the Savoy Hotel to which he, the Princess and Lutyens invited friends, artists and others whom they thought could be involved.

In the meantime, Princess Marie Louise had broached the subject with Queen Mary, the intended recipient. The Queen 'was extremely surprised at first

but then her artistic and historical sense was fired and she agreed.' Queen Mary also gave her permission for the dolls' house to be displayed in a special gallery at Wembley, in the section known as the 'Palace of Arts'. A small fee would be charged for admission, the proceeds from which would go towards the fund set up by Queen Mary for her myriad charitable activities, including hospitals, schools, orphanages and the Royal School of Needlework. This added another strand to the project and gave the idea for the eventual permanent display of the dolls' house at Windsor Castle, where the admission charge (originally 6d, or 2.5p) would also augment the Queen's fund. Queen Mary asked Princess Marie Louise to act as her personal intermediary between Lutyens and the others involved, so that she could be kept informed of progress. In the event she took the keenest direct interest in the scheme, often visiting the dolls' house while it was being constructed and fitted out.

At the Savoy dinner, where Sir Herbert Morgan was confirmed as chairman of the committee, the promoters received an enthusiastic response, and the idea crystallized of the house being a permanent record of contemporary domestic design. How interesting it would have been to have had a similar

Detail of the Corinthian order on the north front of the dolls' house. Lutyens originally proposed Ionic columns but changed them to the richer Corinthian as the design developed.

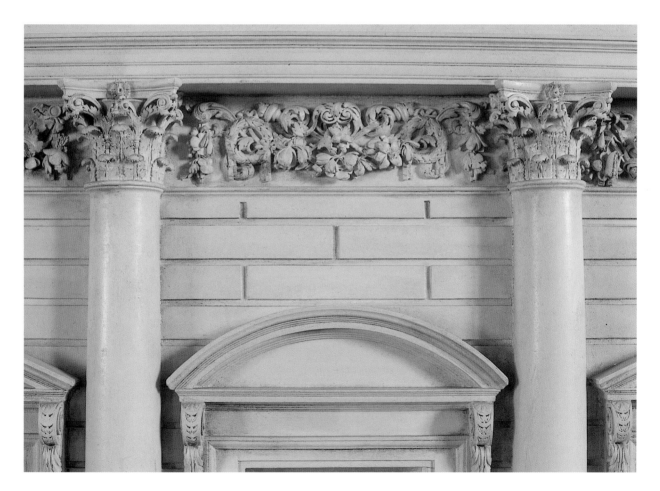

miniature depiction of a Queen Anne or Elizabethan house, or indeed a Saxon hall, with all their domestic arrangements perfectly reproduced. In her memoirs the Princess recorded how Lutyens started to produce plans and designs for the house, drawing on the menus, napkins and tablecloth. That initial sketched-out scheme, conjured up in a moment of prandial enthusiasm was, with few modifications, to become the design of the house as built. The principal change was to be the replacement of the Ionic order of architecture for the house by the richer and more decorative Corinthian. It was not to be a palace with public rooms for ceremonial, or offices for the departments of the household, but a 'gentleman's house' with royal touches and allusions, such as the royal family might have used as their private home. It was also agreed that the work would be paid for by lots of small 'gifts and private donations' and not by large-scale fund-raising. A three-year timetable was fixed for the project.

Another key figure enlisted at the Savoy dinner was Sir Lawrence Weaver, architectural editor of *Country Life*, who was also the Director Designate of the United Kingdom exhibits at the Wembley Exhibition, and responsible for integrating the dolls' house into the display scheme there. He was also to play a large role in the interior fitting of the house, masterminding the furnishings. It is largely due to him, together with the furniture historian and writer Percy Macquoid (1852–1925), who also gave advice, that the interior of the house is such a faithful representation of the cultivated taste of the time, and of the early twentieth-century approach to antique furniture and the arrangement of rooms – what might almost be called in retrospect 'Queen Mary Taste'. The dolls' house is already a record of this vanishing style, which until recently could still be widely savoured in National Trust properties and other houses open to the public, but which has now mainly given way to a more 'historically authentic' approach to old furniture and decoration.

It was Weaver's and Lutyens' decision that everything in the house should be specifically commissioned to a uniform scale of one inch to a foot (that is, 2.5cm to 30.5cm). Some older objects were integrated into its furnishings, but on the whole the donation of any old miniature pieces was discouraged. There was to be no 'rubbish' or 'undesirables.' Much of the furniture was to be copied from famous examples in English private collections – a chandelier from Knole, a table from Chatsworth, beds and clocks at Hampton Court Palace, chairs at Harewood House, a lacquer cabinet from Londonderry House; or scaled-down models of Lutyens' own designs for furniture, as in the kitchen of the dolls' house, or the Broadwood grand piano in the Saloon, which was based on one designed by Lutyens for the British Pavilion at the Paris Exhibition in 1900. (The Pavilion itself was a replica of the Jacobean Kingston House at Bradford-on-Avon).

Sir Lawrence Weaver (1876-1930). The director of the United Kingdom exhibits at the Wembley Exhibition, Weaver was responsible for incorporating the dolls' house into the Palace of Art there, where it was visited by well over one-and-a-half million people in seven months. He was also one of the masterminds behind the furnishing of the house.

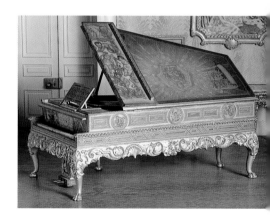

The grand piano in the Saloon. Designed by Lutyens, it is similar to the one he had made by Broadwood for the British Pavilion at the Paris Exhibition in 1900.

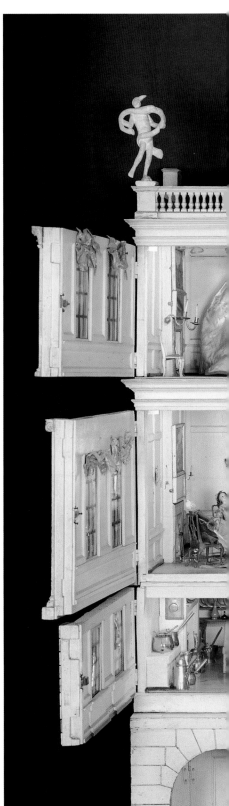

Lutyens took overall command of the scheme. Within a few weeks of the Savoy dinner he had worked up his initial sketch into a complete set of scaled plans and elevations, just like those for a proper building. He also co-ordinated the team of 1,500 craftsmen, artists and tradesmen responsible for executing the work, and took responsibility for much of the financing – guaranteeing up to £11,000 of his own money – until the individual donations came in. After the repayment in 1924 of the £6,300 which he had spent, he confessed to his wife, Lady Emily, that he had been 'rather fearful of death before repayment as it would have hit me badly'.

The structure of the house was made by Parnell & Son of Rugby, using Lutyens' plans just as they would have done if erecting a real building or an architect's model. In this way, the house forms a domestic pendant to the spectacular wooden model of Lutyens' design for the Roman Catholic Cathedral of Liverpool, which is one of the most important architectural models ever created.

The tradition of architectural models to scale in wood goes back to the early Renaissance and many important architectural designs, which were never completed or were superseded, survive now only in this form. They include Bramante's design for St Peter's, Rome, or Wren's Great Model (1673) for St Paul's

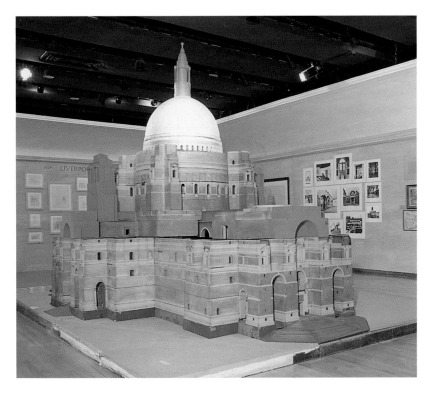

Wooden model of Lutyens' unexecuted design for the Metropolitan Cathedral of Christ the King in Liverpool, *in situ* in the Hayward Gallery as part of an exhibition in 1981. Queen Mary's Dolls' House is in the tradition of large wooden architectural models which can be traced back to the Renaissance.

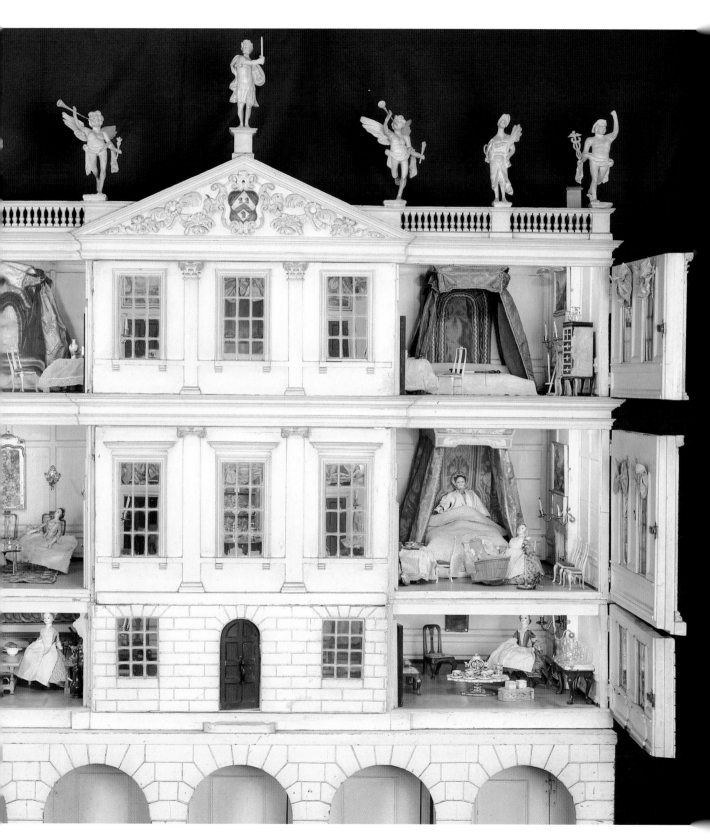

The dolls' house from Uppark, created c.1735.
Elaborately furnished dolls' houses like this
one were an inspiration for Queen Mary's
Dolls' House.

Sir Derek Keppel, Master of the Household from 1913 to 1936. Keppel's patient assistance enabled many domestic items at Buckingham Palace, such as linen tablecloths, to be copied in miniature for the dolls' house.

Cathedral. Queen Mary's Dolls' House combines this serious design tradition with that of English dolls' houses as fully furnished playthings, which reached its peak in the eighteenth-century examples at Nostell Priory in Yorkshire, or Uppark in Sussex. There was a revival of interest in these artefacts in the early twentieth century as part of the general upsurge of enthusiasm for Georgian art and design. This can be seen, for instance, in the journals of the writer Denton Welch, a protégé of the Sitwells. Welch spent many months restoring the wreck of a 'Chippendale dolls' house' which he had been given by an old lady: 'Nothing will look grander than the dolls' house – its perfect classical door, window proportions, heavy Palladian coigning, cornice and then pediment … All these weeks I have been doing it every afternoon (after writing) … One has the feeling that slowly the house is coming to life again.'

Once the timber shell of Queen Mary's Dolls' House was completed, it was set up in Lutyens' Delhi office in Apple Tree Yard, Westminster, and there artists painted the ceilings while craftsmen and decorators all started work on embellishing and fitting the interior. Clare Nauheim and Beatrice Webb, administrative assistants in Lutyens' office, co-ordinated the furnishings, and liaised with the Master of the Household, Sir Derek Keppel, at Buckingham Palace over borrowing items such as table linen or royal china for copying to a miniature scale, or arranging access for artists to paint views of the interior of Windsor Castle to hang in the house. Others were enlisted to help at this stage, such as Lady Jekyll, Gertrude Jekyll's sister-in-law, who was asked to advise on filling the store rooms, and on stocking the Kitchen. She was obviously regarded within the Lutyens' circle as an expert on 'domestic science' and even wrote a miniature recipe book, of dishes suitable for dolls, to go in the house.

Reading some of the correspondence it is possible to deduce between the lines an almost pained patience on the part of the military Sir Derek who, one feels, may have considered that some of the more fanatical concern for accuracy was getting out of hand. Princess Marie Louise herself assumed responsibility for one of the more daring bits of extraction for copying – that of the King's dispatch boxes, used for his official documents. Miniatures of them were to be provided for the desk in the dolls' house Library (see page 38). When King George V, on seeing the finished miniatures, asked who had given her permission to copy them, Marie Louise replied that nobody had, she had just asked for them. The King was surprised but amused.

Edward Verrall Lucas (1868-1938) was an old friend of Princess Marie Louise and a well-known essayist and literary figure in the 1920s. He helped the princess commission a representative selection of works from leading contemporary writers for the Library.

The Creation of the Library

Princess Marie Louise was also personally responsible for one of the most interesting and important aspects of the whole project, the commissioning of a representative range of works by contemporary authors and artists for the Library, the former in the form of autograph works in tiny bound volumes, and the latter in the form of miniature drawings, watercolours and etchings for two folio cabinets. Lutyens himself presented a tiny set of his plans for the house. In this task the princess, as honorary librarian of the house, was assisted by an old friend, the essayist and editor Edward Verrall Lucas, who was a well-known figure in literary circles in the 1920s. Princess Marie Louise wrote letters in her own hand (2,000 in all) to a selection of contemporary talent and had a good response.

Even looking back today, with the benefit of hindsight, the miniature Library of the dolls' house still appears as a remarkably balanced cross-section of the literary life of the period. It contains works by 171 authors, including such well-known figures as Thomas Hardy (who sent nine of his poems), Rudyard

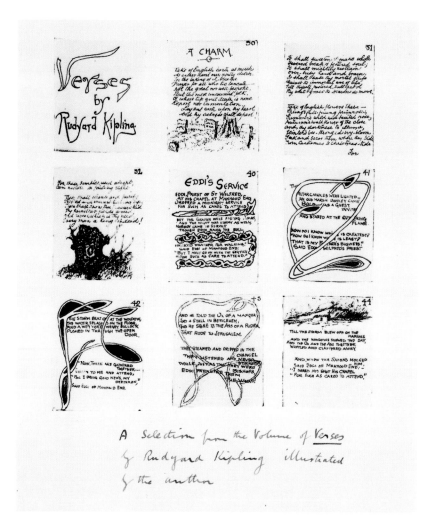

Verses written and illustrated by Rudyard Kipling, which formed his contribution to the Library.

Sir William Nicholson (1872-1949), the most distinguished of the artists who contributed to the dolls' house. As well as miniature paintings, Nicholson was responsible for the murals of the Garden of Eden in the upper part of the Hall.

Kipling (an unpublished set of verses in his own hand), Arnold Bennett, Hilaire Belloc, G. K. Chesterton, Laurence Binyon, A. E. Housman, Siegfried Sassoon, W. S. Maugham, Sir Arthur Conan Doyle (a Sherlock Holmes story), Edmund Gosse, the Bensons, John Buchan, Aldous Huxley, Ronald Knox, Walter De La Mare, Edmund Blunden, Sir James Barrie and Robert Bridges (then the Poet Laureate), as well as lesser, but still remembered names such as Oscar Browning, H. Rider Haggard, Maurice Baring, Anthony Hope, M. R. James or Mrs Belloc Lowndes. Many of them contributed works specially written for the dolls' house Library, and all were printed in full in the *Book of The Dolls' House Library*, compiled by Lucas in 1924 (one of two volumes which formed the official record and history of the house when it was completed).

The authors entered into the spirit of the occasion. Thomas Hardy wrote to Princess Marie Louise: 'I am much pleased with the look of the miniature book, in which I have put my name. It makes one wish to have a whole library of such books.' Only one author refused to contribute, and 'in a very rude manner' – cranky old George Bernard Shaw. A. E. Housman in 1923 perhaps summed up the general feeling behind the response: 'My old, dear and intimate friend Princess Marie Louise, who is furnishing the Queen's Dolls' House, asked me some months ago to let twelve poems of mine be copied small to form one volume in the library; and I selected the twelve shortest and simplest and least likely to fatigue the attention of the dolls or the illustrious House of Hanover.' G. K. Chesterton referred to the project as a 'national and historic object ... I have been only too much honoured to help.' The Library also contained music, including scores by contemporary English composers such as Sir Arthur Bliss, Gustav Holst, Sir Arnold Bax, Hubert Parry and even the noted eccentric Lord Berners. Again there was one notable exception, and rather surprisingly that was Sir Edward Elgar. The writer and war poet Siegfried Sassoon (who did not care for Elgar, having been verbally attacked by him at a party held by Lady Maud Warrender), reported that in a 'crescendo climax of rudeness' Elgar said 'we all know that the King and Queen are incapable of appreciating anything artistic; they have never asked for the full score of my Second Symphony to be added to the library at Windsor. But as the crown of my career I'm asked to contribute to – a Dolls' House for the Queen! ... I consider it an insult for an artist to be asked to mix himself up in such nonsense.'

Seven hundred artists did get 'mixed up', however, and provided little pictures for the house. They have not all stood the test of time as well as the authors, and many of their names are now almost forgotten. This may be because the intention was to commission works from across the British Isles, including provincial art centres such as the West of England Academy at Bristol,

the Shrewsbury School of Art or Newcastle College of Art, and from the colonies, as well as from established artists in London. There was also a substantial representation of humorous work which, by its nature, tends to be more ephemeral; and in the case of some of the older artists' approached, including John Singer Sargent, Charles Ricketts or Charles Haslewood Shannon, their eyesight did not allow them to work on a miniature scale. For whatever reason, some of the most notable early twentieth-century artists are absent from the dolls' house, including Sir Frank Brangwyn and Sir Stanley Spencer, though possibly the greatest – Sir William Nicholson – is prominently represented.

The best art in the collection is the mural decoration by Glyn Philpot, Professor R. Anning Bell and Nicholson, or the oil paintings hanging on the walls by Royal Academicians such as Sir Alfred Munnings, Sir John Lavery, Sir William Orpen and Ambrose McEvoy. The folio cabinets contain etchings and engravings by the likes of Burleigh Bruhl, Talbot Kelly, G. S. Lumsdun, Frank Short and Sidney Tushingham, and Scottish and Irish watercolours by Percy Lancaster, Graham Petrie, and Murray Urquhart (whose names are now known mainly to specialists), as well as works by better-known artists such as Sir William Russell Flint, Mark Gertler, Dame Laura Knight, Paul Nash and Sir William Rothenstein.

As the work progressed, it gathered a momentum of its own and attracted supporters and donors. One such was the connoisseur Edward Knoblock, an American by birth who lived at the Beach House, Worthing, after 1918. Knoblock was one of the more notable furniture collectors of the age and

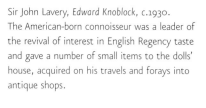

Sir John Lavery, *Edward Knoblock*, c.1930. The American-born connoisseur was a leader of the revival of interest in English Regency taste and gave a number of small items to the dolls' house, acquired on his travels and forays into antique shops.

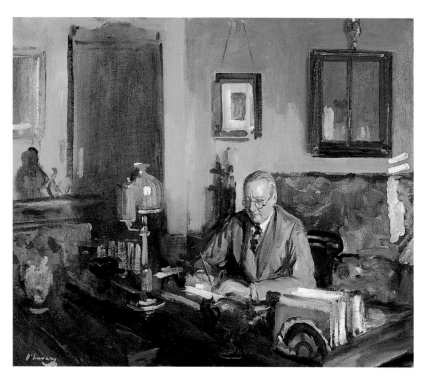

the acknowledged pioneer of the Regency revival in England, owning important early nineteenth-century items from Thomas Hope's houses. He wrote enthusiastically and offered various items. He also wrote a little play for dolls for the Library, exclaiming: 'What a delicious house it will be when done.' He sent the committee a set of little prints and a 'tiny pack of playing cards I came across', adding nonchalantly 'During my yachting trip I shall keep a look-out for any other suitable little articles.'

Lutyens continued to immerse himself in a great deal of detail. It was at his insistence that everything in the house was made to work, including the goods and passenger lifts, the electric lights and the major plumbing. He designed a sub-base on which the house could stand, containing drawers for

The dolls' house in the drawing room in Lutyens' own house in Mansfield Street, London, where the completed shell of the dolls' house stood for two years while the furniture and contents were assembled.

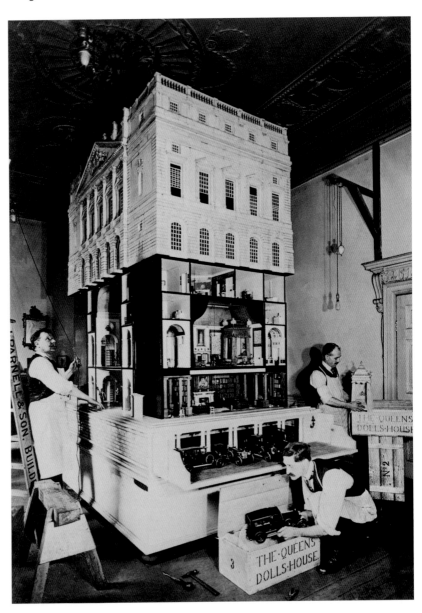

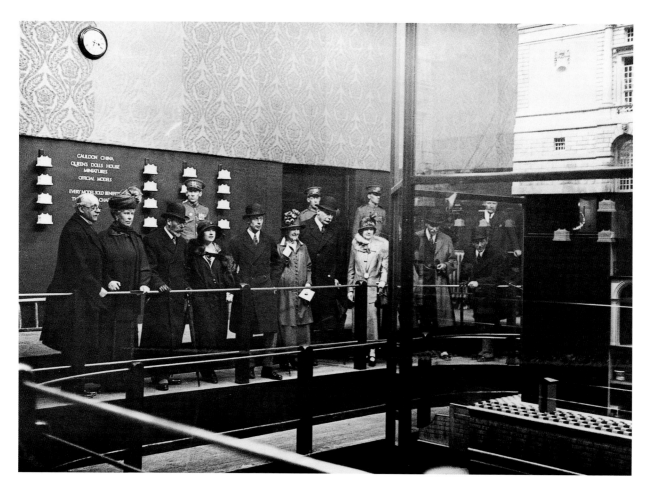

The house on display at the British Empire Exhibition at Wembley. It was there from April to November 1924. On the wall behind can be seen official souvenirs in the form of little china models by Cauldron Pottery. The house was subsequently shown at the *Daily Mail*-sponsored Ideal Home Exhibition at Olympia in 1925. Here the royal party, including Queen Mary and King George V and the Duke and Duchess of York, are accompanied by Sir Edwin Lutyens (on the left).

dolls and overflow items, but also the electric generator and the water tank. The mechanical engineer was A. J. Thomas. Lutyens was also helped in providing working drawings by his draughtsman F. B. Nightingale. George Muntzer, the head of a well-known West End firm of upholsterers and decorators, much used by Lutyens in his houses, was the honorary decorator.

Once the structure and architectural embellishments were complete, the dolls' house was moved to Lutyens' own house in Mansfield Street, Marylebone, where it occupied the drawing room for two years while the furniture and other contents were assembled. Queen Mary took a great personal interest, visiting frequently, and once staying for over four hours, 'arranging and playing with everything'. The house was completed, with every item in place, eleven weeks before the opening of the British Empire Exhibition. It was unveiled to the press on 8 February 1924 and had a good reception. The house left Mansfield Street in March, all the items being packed up in specially made wooden boxes, ready for the opening at Wembley in April, where it was put on display until November. During this period it was visited by no fewer than 1,617,556 people. The intention was then to exhibit the house permanently at Windsor Castle, in a former china store near the north entrance, which was to be adapted for the purpose. At this

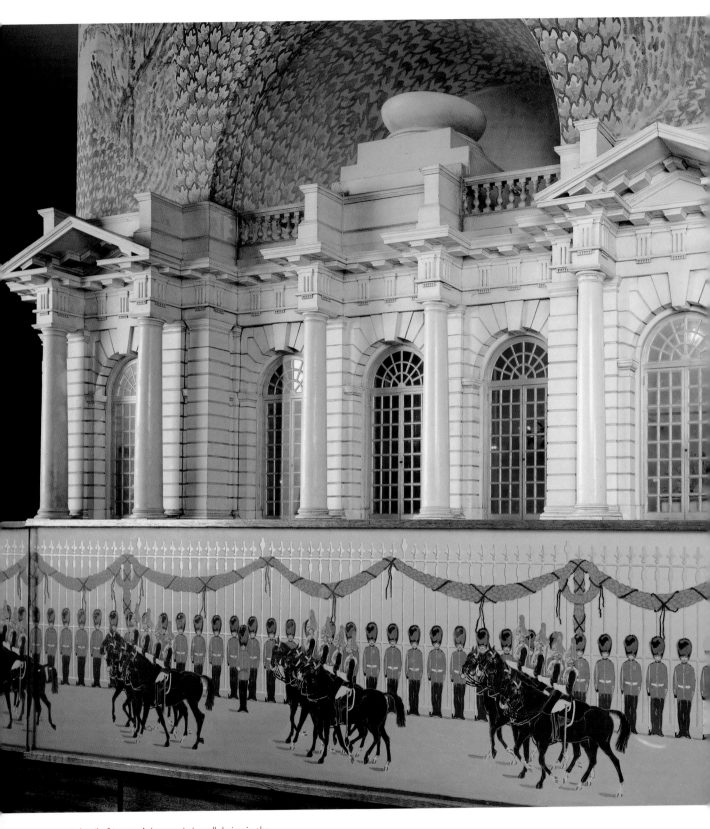

A detail of Lutyens' characteristic wall design in the
Windsor exhibition room. The murals were painted by Philip
Connard, well known at the time for his decoration of
great ocean liners.

stage, however, permission was requested to exhibit it in 1925 at Olympia for the *Daily Mail*-sponsored Ninth Ideal Home Exhibition. The *Daily Mail* commissioned a large Pilkington-glass case in which to show the dolls' house, and this second public exhibition gave Lutyens time to prepare the new space at Windsor for the house's ultimate reception.

All was ready by July 1925. The *Daily Mail* offered the new glass case from Olympia for the permanent display of the house, in which it remains today. It is of some historic interest in itself as an example of Pilkington's 'flat' glass, a novel patent process which made possible the huge sheets of plate glass that were to become a feature of twentieth-century architecture, though not of Lutyens'. The dolls' house has remained at Windsor ever since, though the contents were taken to the Victoria and Albert Museum and to the Science Museum for an overhaul in 1972. The room in which it is displayed has architectural features by Lutyens and murals painted by the fashionable decorative artist Philip Connard (1875–1958), who also worked on the *Queen Mary*. The house, because of its construction with natural materials, and protection from daylight, survives in an excellent state of preservation, both as a delightful period piece and as an increasingly interesting historical record – exactly as its promoters intended.

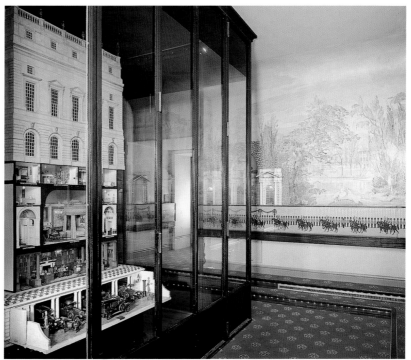

The exhibition room at Windsor Castle. The show space was designed by Lutyens. The Pilkington glass case was made for the Ideal Home Exhibition, and presented to Windsor Castle by the *Daily Mail* for the permanent protection of the dolls' house.

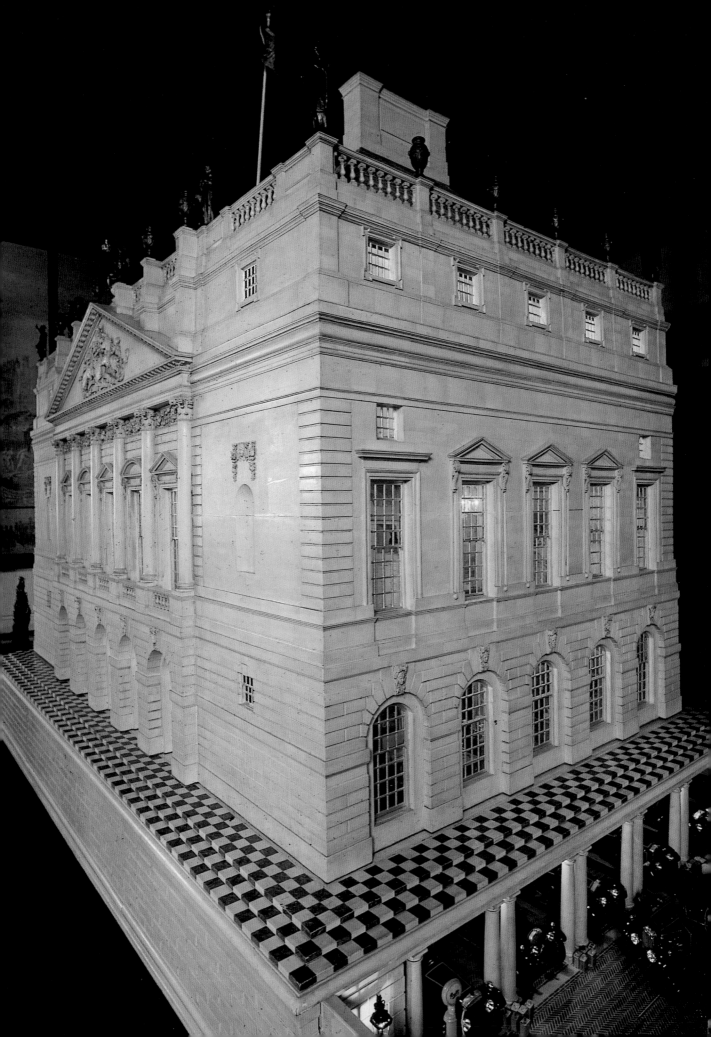

AN ILLUSTRATED TOUR

The Exterior

QUEEN MARY'S DOLLS' HOUSE stands on a 2 foot (61cm) high, black-painted, sub-base designed by Lutyens, containing 104 cedar-wood drawers for storage, as well as the house's mechanical services. Above that is a rusticated plinth which forms part of the house proper, containing in its basement the wine cellar. At either end are pull-out fall-front drawers: that on the west side containing the garage and that on the east the garden. The house proper is three main storeys high, with the principal façades facing north and south. (On entering the exhibition room, the visitor sees the west side first.) The exterior forms a detached case which can be raised up above the house by electrically powered machinery (hidden in the roof), so as to reveal the interior. The façades are built of wood painted to resemble Portland stone, but the roof itself is made of real Welsh slates, cut to tiny proportions.

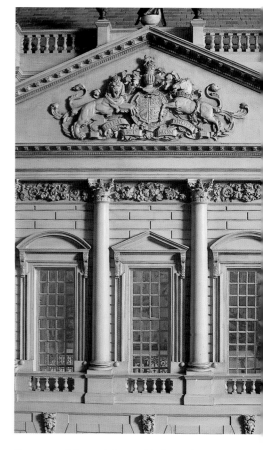

The centre of the north front, with the royal arms in the pediment. All the glazing bars in the sash windows are gilded.

Built to a consistent Imperial scale of one inch to one foot, the principal elevations to north and south are 102 inches (2.59m) wide, and the side elevation is 58.5 inches (1.49m) wide. The house proper is 60 inches or 5 feet (1.52m) high to the top of the parapet. All the proportions were worked out by Lutyens to the strict mathematical rules which governed his architecture. The plan of the house is an exercise in architectural symmetry and this is reflected in the exterior, the pattern of the windows indicating the disposition of the rooms inside, and the presence of little additional mezzanine floors in the corners. It is a sign of Lutyens' intellectual rigour that there are only two blank windows on the outside and no unlit spaces within. The windows are real and light the rooms, though some of the large windows run through two mezzanine storeys. Lutyens, however, had architectural fun in devising surface variations between the four faces of the house.

A characteristic Lutyens detail is the classical *entasis*, whereby each of the three main stages of the elevations is set back slightly, creating an overall and barely discernible tapering effect. There are many other subtleties, such as the treatment of the 'masonry' to suggest recessive planes, with the rustication of the ground floor having five different surfaces, or the way in which the cut-back aprons or panels below the first-floor windows of the north side step down into a double string course. By these and similar means Lutyens gives his architectural elevations life. All this abstract geometry underlies the more obvious classical embellishment of the façades, such as the pediments over the central windows, the carved keystones, the balustraded parapets and the five-bay Corinthian centrepieces of the north and south fronts; the former's pre-eminence being established by a pediment containing the royal arms, while the latter has Queen Mary's own arms over the central window which lights 'her' bedroom.

The roof is covered with tiny but real Welsh slates, though the walls are of wood painted to look like Portland stone.

The use of the Corinthian order for the columns on the outside of the house is one of the few changes from Lutyens' initial rapidly sketched proposal, which had shown Ionic columns. The north and south elevations pay distant tribute to Inigo Jones's Banqueting House in Whitehall and Wren's east and south fronts for Hampton Court Palace, key seventeenth-century English royal buildings, but they are not in any way direct copies. Lutyens had an incredible visual memory and his creative process was able to draw on quotations from any building he had ever seen at an almost subconscious level. Thus these seemingly simple classical elevations are in fact architectural exercises of great complexity, subtlety and richness, which have parallels to Lutyens' designs for the British Pavilion in Rome and his contemporary elevations for Britannic House in Finsbury Circus (1920–22).

One or two other little details of the exterior are worth noting. There are two symmetrical chimneystacks on the roof (not visible when the house is open) which have flues to serve all the fireplaces in the house (all the main rooms have fires). The parapet is crowned with lead urns and statues. The four corner statues are the patron saints of the British Isles: St George and St Andrew (north), and St Patrick and St David (south). Over the centre of the north front is an angel bearing the Queen's crown. The other four figures are emblematic of Queen Mary's Christian names: Mary, Louise, Victoria and Augusta. They are all the work of the sculptor Sir George Frampton. The flagstaff flies Queen Mary's personal standard with her arms, while the gilding of the glazing bars adds a final royal touch. All the sashes are double-hung and can open. Finally, the four sentry boxes have guards' instructions inside copied from those at Buckingham Palace.

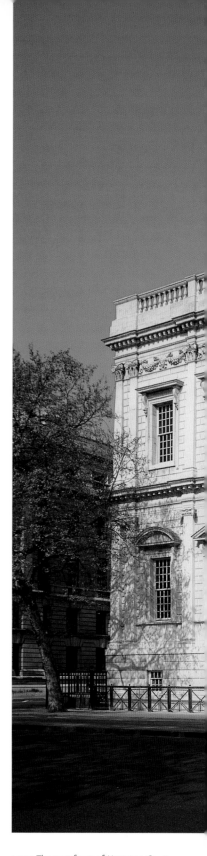

LEFT: The east front of Hampton Court Palace, built by Sir Christopher Wren in 1690, a source for the north front of the dolls' house, with a carved pediment set against the attic storey.

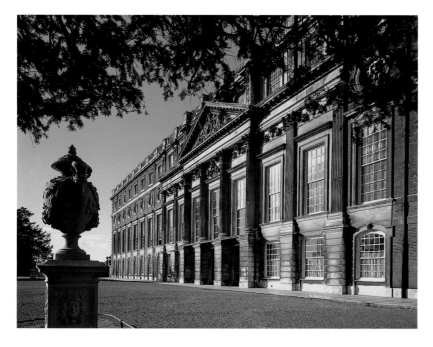

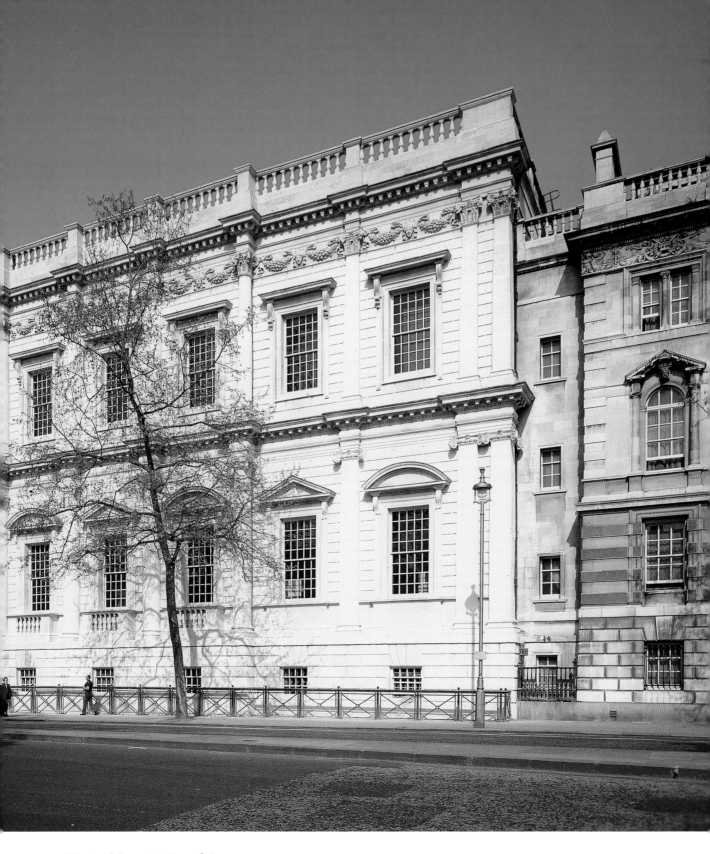

ABOVE: Inigo Jones's Banqueting House of 1619 in Whitehall. A seventeenth-century royal building which was one source of inspiration for Lutyens, with its alternating triangular and segmental pediments over the windows and frieze of carved swags between the capitals of the columns.

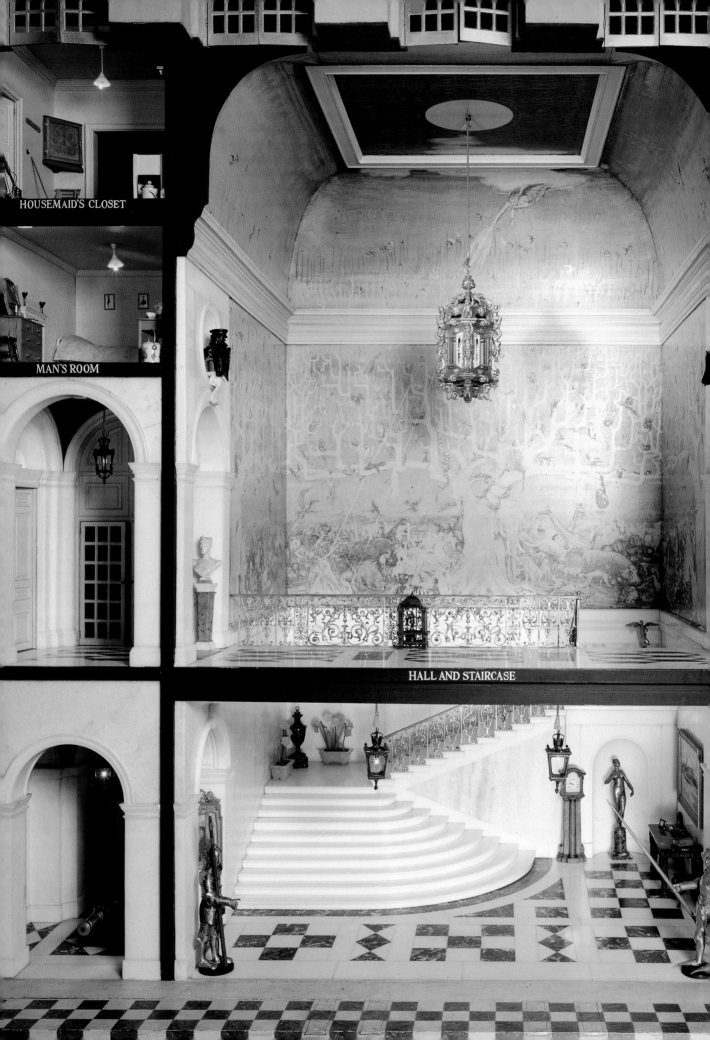

HOUSEMAID'S CLOSET

MAN'S ROOM

HALL AND STAIRCASE

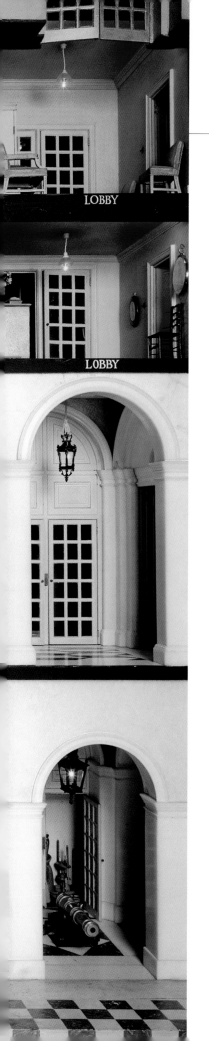

LOBBY

LOBBY

THE GROUND FLOOR

THE ENTRANCE HALL

HAVING ENTERED THROUGH THE MAIN GLAZED DOOR in the middle of the north front the visitor is in the Entrance Hall, with Lutyens' staircase straight ahead. This is spatially the most impressive part of the house, rising through the three principal storeys with arched lobbies to either side at ground and first-floor level. In plan it is a perfect square of 20 inches (50.8cm). At ground-floor level it is splendidly marmoreal: the walls are lined with white and pinkish marble while the stairs are pure white, and the floor is an ingenious pattern of alternating squares and diamonds of white marble and blue lapis lazuli. (The Indian Government gave a batch of twenty different coloured marbles for use in the house.)

The staircase itself is a characteristic Lutyens design whereby the bottom step is two-thirds the width of the room, and the lower flight then tapers to the narrower width of the upper flights, a variation of the theme that can be seen in some of his real houses such as Gledstone Hall in Yorkshire. The silvered balustrade, inspired by Jean Tijou's ironwork at Hampton Court Palace, was made and given by the leading Arts and Crafts metalworker J. Starkie Gardner, who also worked at the Palace of Holyroodhouse. The underside of the landing was painted with the heavens and twelve signs of the Zodiac in blue, white and gold. The bronze statue of Venus, on a lapis lazuli plinth, in the niche beneath the stairs is by Francis Derwent Wood, who was Professor of Sculpture at the Royal College of Art from 1918 to 1923.

The furniture in the Entrance Hall forms a good introduction to that found throughout the house, mainly comprising fine-quality 'antiques'. The two lacquered hall chairs (with the royal arms) and the marble-topped side table were inspired by the hall furniture at Blenheim Palace. The longcase clock is a copy of a seventeenth-century example by the famous clockmaker Thomas Tompion. It is one of seven clocks in the house made and presented by Cartier, which are all capable of keeping time. The two wrought-iron hall lanterns with crowns were designed by Lutyens. The suits of armour are among the few objects in the house that seem slightly out-of-scale. The painting of Windsor Castle, which has the bright colours of a contemporary Batsford book jacket, is by Sir David Young Cameron, who became the King's Painter and Limner in Scotland from 1933 to 1945.

The centre of the north side of the dolls' house, showing the Hall and Staircase with flanking lobbies.

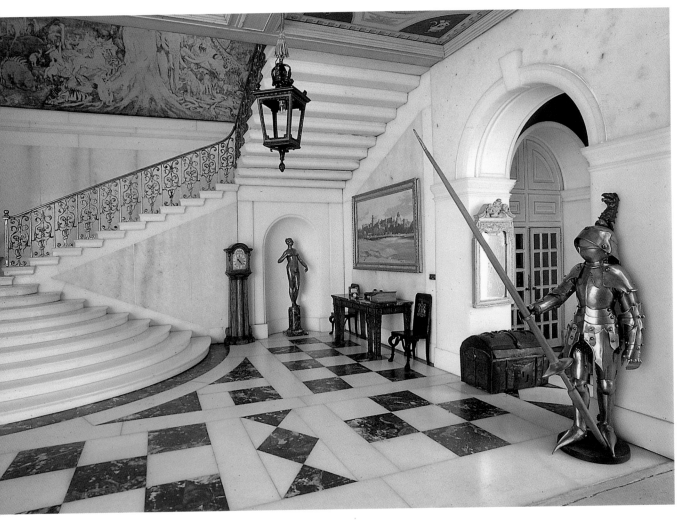

ABOVE: The furniture in the Entrance Hall was copied from examples at Blenheim Palace, Oxfordshire.

Although the house has no guest rooms, there is a visitors' book on the hall table with an ink stand, so that departing dolls can sign their names. Glazed doors from the lobbies to either side of the hall give access to the secondary staircase to the left (which serves all floors), and to the passenger and service lifts to the right. The lobby leading to the lifts has the hall porter's chair, with his copy of the *Daily Mail*. The electric-powered lifts, made by Otis, are still in working order. There is also a games cupboard with miniature golf clubs, croquet set, bats and rackets, all by the best makers.

BELOW: Visitors' book, ink stand and calendar on the hall table.

The games cupboard with miniature golf clubs, croquet mallets and tennis rackets.

THE DINING ROOM

CONTINUING ROUND THE HOUSE in a clockwise direction, the Dining Room is reached. It faces east, overlooking the garden. It is an 'Inigo Jones' style room, though not like any room Inigo Jones actually designed, with its compartmented ceiling, panelled walls with curved 'bolection' mouldings and carved limewood festoons, and bolection chimneypiece of white and Siena marble.

The walls were painted and gilded by Muntzer's, who did all the house painting and upholstery. The overdoors are painted mainly in monotone grisaille with vases and cherubs, and the ceiling panels, containing classical scenes of fauns, nymphs and satyrs, are by Professor Gerald Moira.

The oil paintings in the Dining Room include some of the finest in the house, especially the three on the fireplace wall, which are miniature copies of his own work by Sir Alfred Munnings, and depict the Prince of Wales (later Edward VIII) hunting, a prize Friesian bull and the King's charger, Delhi. The copy of Winterhalter's *The Royal Family in 1846* (the original is at Buckingham Palace) is by Ambrose McEvoy, and the portraits of Edward III and James V of Scotland are by Sir William Llewellyn. The flower piece over the buffet is by

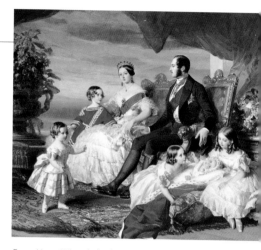

Franz Xaver Winterhalter's painting of *The Royal Family in 1846*, copied for the Dining Room of the dolls' house.

The Dining Room, showing the screen made by Cartier out of Indian playing cards presented by Edward Knoblock.

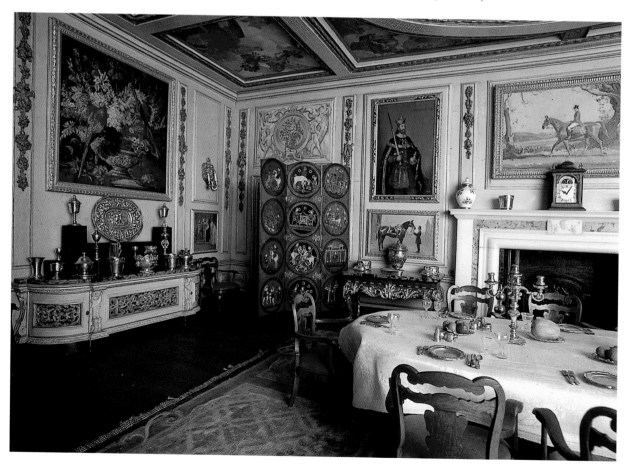

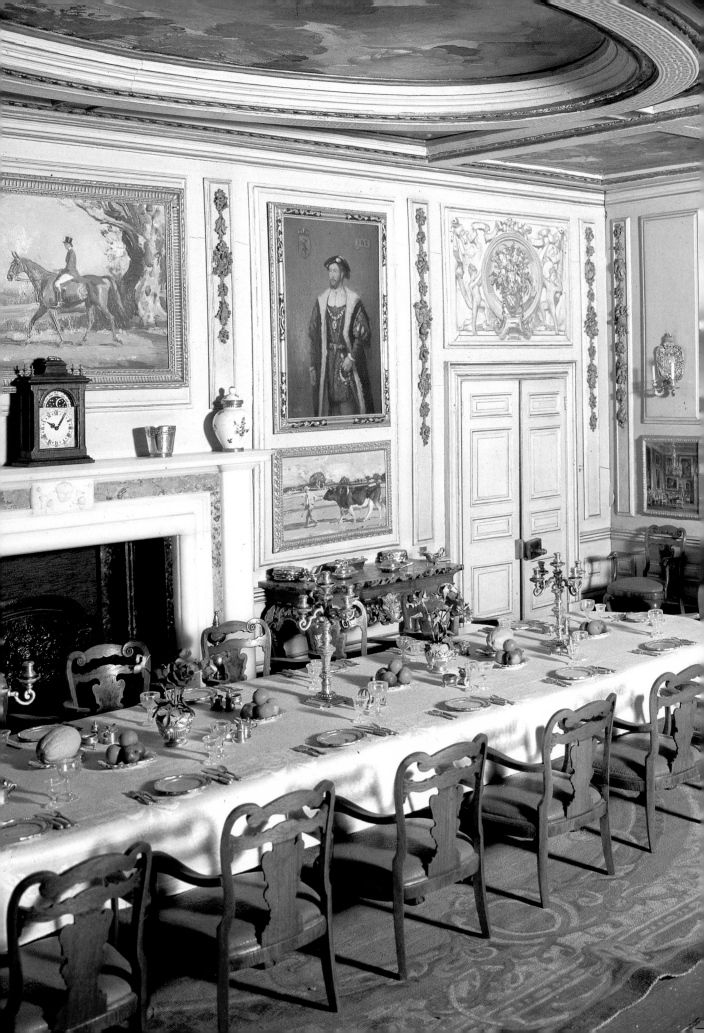

W. B. E. Ranken. The smaller pictures in the lower tier include two views of King George V's coronation by a Captain Pearse (a New Zealand artist) and two views of the state apartments at Windsor, also by W. B. E. Ranken. The long panel under the 'Winterhalter' is by the portrait painter Glyn Philpot (1884–1937).

The furniture is also distinguished, and reflects early eighteenth-century English styles. The set of three carved and parcel-gilt side tables with lions'-paw feet have verd-antique marble tops. The set of eighteen walnut chairs have carved eagle's heads terminating their arms and salmon-coloured leather upholstery. The dining table extends to 20 inches (50.8cm) when fully open. The carved buffet was designed by Lutyens, as was the tall red-lacquer Indian screen, made by Cartier of real eighteenth-century Indian *ganjifa* playing cards, given by Edward Knoblock. The carpet, an imitation Aubusson, was made and presented by Ernest Thesiger, an actor and colourful man-about-town, who had a keen interest in needlework.

The table in the Dining Room is set for dinner. The linen tablecloth with the royal cypher, Garter Stars, shamrocks and thistles (representing British orders of chivalry), was woven in Belfast on the pattern of those at Buckingham Palace. The silver dinner service (for eighteen) was made by Garrard's (the Crown Jewellers), while the glasses are Webb's crystal and were given by Thomas Goode & Co Ltd. The four silver wall sconces are copied from examples at Windsor Castle. The show silver on the buffet includes a Monteith bowl (a bowl with a detachable scalloped rim for holding glasses) and 'Elizabethan' cups and covers and coconut cups, many of them presented by the craftsmen who made them. The Garrard's service (including extra pieces stored in the Strong Room) cost £280 and was paid for in cash by Sir Herbert Morgan, chairman of the Dolls' House Committee.

The door to the left of the chimneypiece, partly concealed by the Indian screen, leads to the Servery, Butler's Pantry and Kitchen.

LEFT: The Dining Room with white and gold wall panelling and compartmented ceiling of what might be termed Inigo Jones' Anglo-Palladian inspiration. Over the chimneypiece is an equestrian portrait of the Prince of Wales, later King Edward VIII, by Sir Alfred Munnings.

RIGHT: Detail of a table setting with silver by Garrard's, Crown Jewellers from 1843.

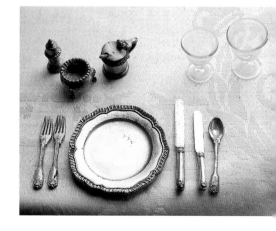

THE SERVICE ROOMS

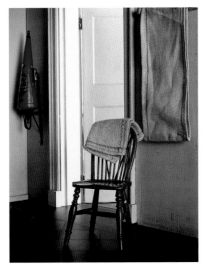

Towels, a Windsor chair, and a Minimax fire extinguisher. The open door leads to the Kitchen.

THE SERVICE ROOMS IN THE DOLLS' HOUSE are very similar to those in other Lutyens houses, Castle Drogo in Devon for instance, with cupboards, shelves and other fittings designed by the architect himself. They are among the most intriguing and amusing of all the rooms in the house.

The Servery, where food was kept warm, has wooden tables, a hot-plate and other essential equipment including, interestingly, a cocktail-shaker, which would then have been a novel detail in an English house, as drinking cocktails had only been introduced to England as a fashion from America after the First World War. (Hot canapés at parties was another American innovation of the time.) The Servery links directly and conveniently to the Butler's Pantry and the Kitchen.

The Butler's Pantry occupies the north-east corner of the house with the Strong Room for plate on the mezzanine floor above it (reached via the back stairs).

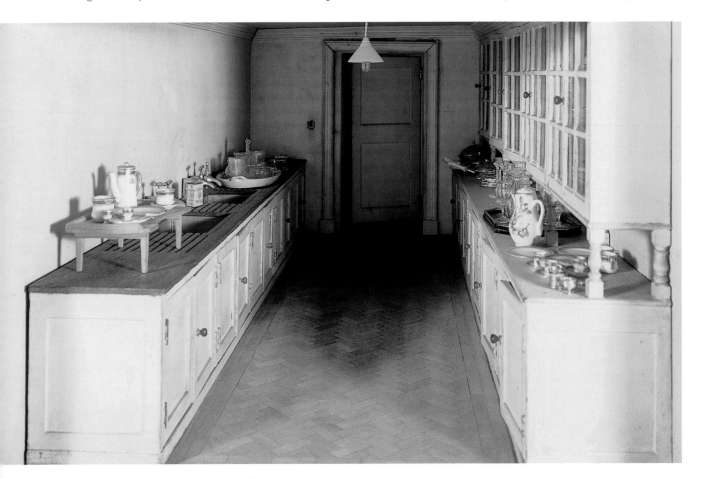

The Butler's Pantry, with cupboards designed by Lutyens, Doulton china and a miniature tin of Colman's mustard.

The pantry contains two sinks, with wooden draining-boards, for washing the silver, glass and china. The best china, made by Doulton and presented by Thomas Goode, is stored in the cupboards below the sinks and includes four dinner services, two breakfast services, a dessert service, and a coffee service. There are separate drying cloths for china and glass and a roller towel. Decanters, water jugs, and entrée dishes stand ready for filling. There is even a Minimax fire extinguisher fixed to the wall, ready for an emergency.

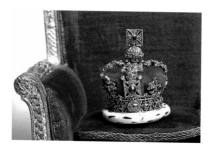

Miniature copy of the Imperial State Crown, set with tiny diamonds, on one of the thrones in the Saloon.

The Strong Room includes most of the silver dinner service, a tea service on a silver tray with an Abercorn-pattern tea-kettle, as well as additional display pieces such as a gold Monteith bowl. There are also miniature copies of the Crown Jewels with real diamonds – a little joke on the Committee's part.

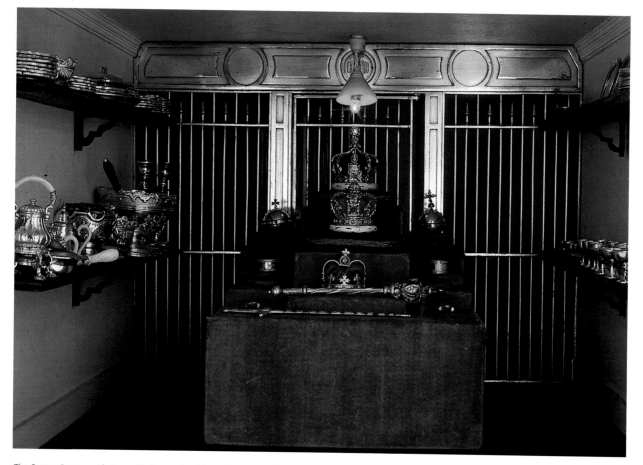

The Strong Room, with Garrard's silver and miniature Crown Jewels; the latter were a characteristic light-hearted touch on the part of the Committee.

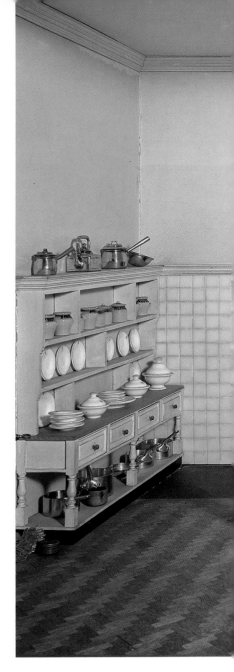

The Kitchen has several Lutyens features including the wood-block floor and the furniture. The floor is made of 2,500 tiny wooden blocks in a parquet pattern. Lutyens preferred wood blocks to tiles for kitchen floors as being less slippery. As would have been normal in kitchens of this period, the walls are tiled to half height. The furniture comprises painted wooden dressers and a large oak kitchen table designed by Lutyens, and identical to that once in his own house, while the dressers are similar to those at Castle Drogo. The clock hanging on the wall above the fireplace is also a typical Lutyens design. The polished steel stove, with two ovens and separate hot-plate and pastry oven, is a coal-burning model known as an 'English Range'.

The Kitchen contains its own Doulton china service, marked with a *K*, and a wide range of equipment, including a copper *batterie de cuisine* and a mincing machine, weighing scales, and coffee-grinder (made by the Winning Model Co.), wooden rolling-pin, mops, brushes and carpet sweeper, all still recognizable if now rather old-fashioned. The house also possesses what was then a very modern device, an electric Hoover vacuum-cleaner. Note the cat and other details such as a mousetrap, little (ivory) mice, and the W. H. Smith calendar. Many of the provisions in the service rooms – Colman's mustard, Cooper's marmalade or Lifebuoy soap – are still household names, and were all chosen by Lady Jekyll.

The Scullery beyond the kitchen was for washing the kitchen pots and pans, as opposed to the dining-room china which would have been washed in the Butler's Pantry. It is fitted with sinks, wooden draining-boards, cupboards, plate-racks, scrubbing brushes, soap and towels. It also has what was then the newest type of refrigerator.

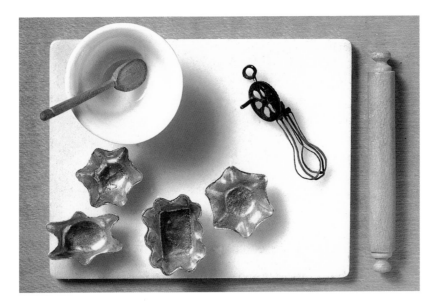

ABOVE: The Kitchen, with its non-slip wood-block floor, clock, table and dressers – all designed by Lutyens and similar to examples by him in full-size houses.

LEFT: Copper moulds, hand whisk and mixing bowl, rolling-pin and marble slab for pastry on the kitchen table.

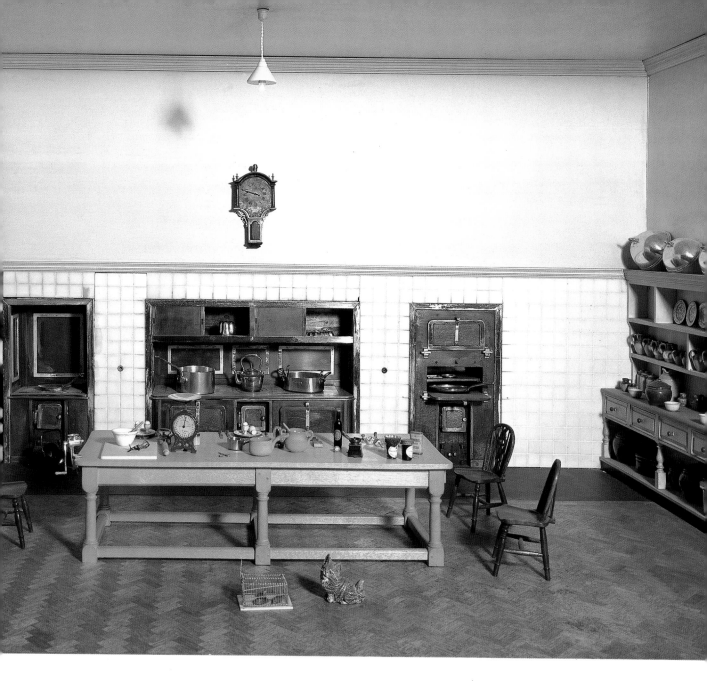

LEFT: The dolls' house cat, with three mice (in a humane trap).

ABOVE RIGHT: Three copper kettles from the complete *batterie de cuisine* in the Kitchen.

BELOW RIGHT: Two of the Doulton dolls' house plates, shown on the rim of a modern, full-scale royal plate.

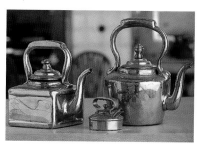

THE LIBRARY

OCCUPYING THE FULL WIDTH OF THE WEST SIDE at ground-floor level, 45 inches (114cm) long and 21 inches (53cm) wide, the Library is both by reason of its architecture and its contents one of the more impressive spaces in the house. It is lined with Italian walnut, including the fitted bookcases and the screens of fluted Ionic columns at either end, which Lutyens introduced to give interest to the space. The chimneypiece is of white marble and lapis lazuli. This room is to some extent like a London club, and appears to be a masculine den, with pipes and cigars, fencing foils, and a gun cupboard. The 4 inch (10cm) long Purdey guns (the smallest ever made) are laid out, at King George V's own suggestion, on one of the folio cabinets where they can more easily be seen. They were modelled on the King's own guns and donated by Athol Purdey; and came complete with a leather gun case and cartridge bag. Every surface in the Library is cluttered with bric-à-brac: photographs, twelve royal dispatch boxes, bronzes, and a model of George III's yacht, the *Royal George*. The walnut desk has pens, ink and writing paper. There are also newspapers and magazines including *The Times*, the *Daily Mail*, *Country Life* and the *Field*, as well as others now extinct, including the *Strand Magazine* and the *Morning Post*. The safe under the gun cabinet contains an insurance policy for the house – a characteristic humorous touch.

The ceiling was painted by William Walcot, an architectural perspectivist, with, appropriately, 'shadowy hints of old Roman things'. The portraits in the room refer to Tudor patrons of the literary Renaissance, including Elizabeth I (over the chimneypiece), a painting based on the Armada Portrait at Woburn, and full lengths (on the side walls) after Holbein of Henry VII by Frank Reynolds and of Henry VIII by Sir Arthur Cope.

The Library furniture, like that in the Kitchen, was also mainly designed by Lutyens, including the desk and pair of folio cabinets *en suite*, and the red leather upholstered sofa and armchairs. However, the three silver chandeliers

RIGHT: The Library, with walnut furniture and fitted walnut bookcases.

LEFT: One of the folio cabinets in the Library with open drawer to show the collection of mounted drawings and watercolours. On the left can be seen Lutyens' own design of the north elevation of the dolls' house.

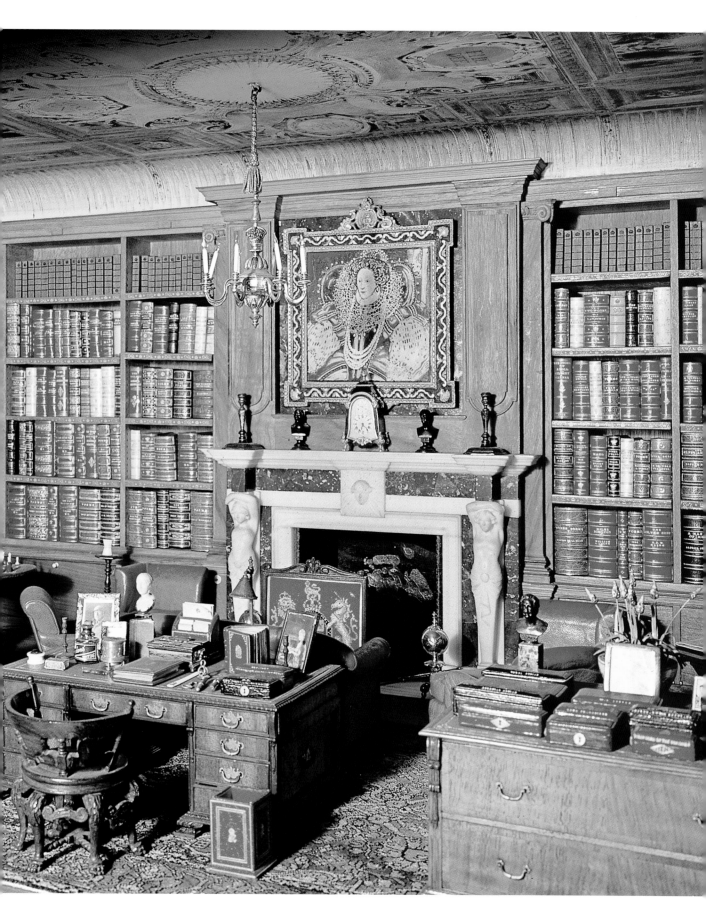

SAINTE-CLAIRE DU CHATEAU
HYÈRES (VAR)
TÉL. 2 29

Madam,

Your Highness' letter reached me with some delay as I live in the South of France in winter.

The doggerel enclosed is unworthy of so charming a destination, but I hope you will be indulgent, in view of the shortness of time allowed for its invention.

Pray believe me, madam,

Your Highness's obedient humble servant

Edith Wharton

March 29th 1922.

Letter of acceptance from Edith Wharton, the American author of *The Age of Innocence* and *Ethan Frome*, dated 29 March 1922, from the Royal Archives, Windsor. Princess Marie Louise herself wrote 2,000 letters asking for contributions to the Library.

Detail of the gold-tooled leather bookbindings and shelf edgings, with the GMR cypher and the royal crown. Seven different binders were employed, most notably Sangorski & Sutcliff.

RIGHT: The dolls' house bookplate was specially designed by the illustrator Ernest Shepard, best known for his drawings for *Winnie the Pooh*.

were inspired by those at the great Kent country house of Knole. The pair of terrestrial and celestial globes show the British Empire coloured pink, at its final and widest extent in 1922. There are three Persian rugs and a moleskin hearth rug. Concealed in one of the cupboards is a wireless, then a very modern invention – King George V's first radio broadcast was the opening speech at the Wembley Exhibition. (Television only became widespread in English homes after the Second World War.)

The books form a collection of 300 volumes, all specially bound by seven different firms, most notably Sangorski & Sutcliff. Apart from the unique autograph works by contemporary authors to represent 'all that is best in the literature of this country at the present moment', there are also a number of old miniature printed books including three Bibles, a Koran, sets of Shakespeare, an English dictionary, English histories, works by the famous Scottish poet Robert Burns and by Charles Dickens, early nineteenth-century English miniature almanacs, miniature *bijou* French children's books, and the smallest book ever printed from type, *The Mite* (1891), published and presented by E. A. Robinson. All the volumes contain a bookplate specially designed for the house by Ernest Shepard, the illustrator of *Winnie the Pooh*. There are also miniature reference books, produced by micro-photography, such as *Bradshaw's Railway Timetable*, *Whitaker's Almanac* and *Who's Who*, together with fifty volumes of music and miscellanea such as a Sandringham Stud Book and two miniature stamp albums. Not usually visible, in the folio cabinets, is the collection of watercolours, etchings and drawings by contemporary artists.

THE FIRST FLOOR

THE UPPER HALL

THIS SPLENDID SPACE IS A PERFECT CUBE of 20 inches (51cm) by 20 inches by 20 inches high. It is distinguished by murals by Sir William Nicholson on the walls and cove of the ceiling. They depict Adam and Eve being expelled by a thunderbolt from the Garden of Eden, mainly in grisaille apart from the pink figures of Adam and Eve themselves. The animals, or 'their pets' as Nicholson described them, are particularly jolly, with pairs of giraffes, elephants, lions, tigers, hippopotami and the like. It took longer to complete than expected and Lutyens had to chivvy Nicholson to finish on time. White marble-lined arches lead to lobbies, and over the arches are bronze busts in roundels of Earls Haig and Beatty, prominent land and sea commanders during the First World War. These are the work of C. S. Jagger (1885–1937), a leading sculptor who worked on many 1920s war memorials. His masterpiece is the Royal Artillery Memorial at Hyde Park Corner. The white marble busts on Siena marble plinths are by Sir W. Goscombe John, and show King Edward VII and Queen Alexandra.

The Upper Hall, with grisaille murals by Sir William Nicholson of Adam and Eve being expelled from the Garden of Eden.

HOUSEMAID'S CLOSET

MAN'S ROOM

LOBBY

LOBBY

HALL AND STAIRCASE

THE SALOON

THE LEFT LOBBY OF THE UPPER HALL gives access to the Saloon, the principal reception room, which fills the whole of the east side of the house and rises into a high coved ceiling. As in the Dining Room below, the architectural inspiration is derived from Inigo Jones, with a Palladian panelled ceiling, and a two-tier, plum and white Indian marble chimneypiece, supported on Corinthian columns and culminating in a broken pediment, on the slopes of which recline little marble *putti*. The carving is a virtuoso display of minute accuracy.

The ceiling panels and cove were painted by Charles Sims, who was Keeper of the Royal Academy Schools from 1920 to 1926, to represent 'The children of Rumour with her hundred tongues'. The coving has a lattice pattern

BELOW: The Saloon is the most splendid room in the house, with a high coved ceiling and walls hung with what was originally rose-coloured silk, now faded to a golden-yellow.

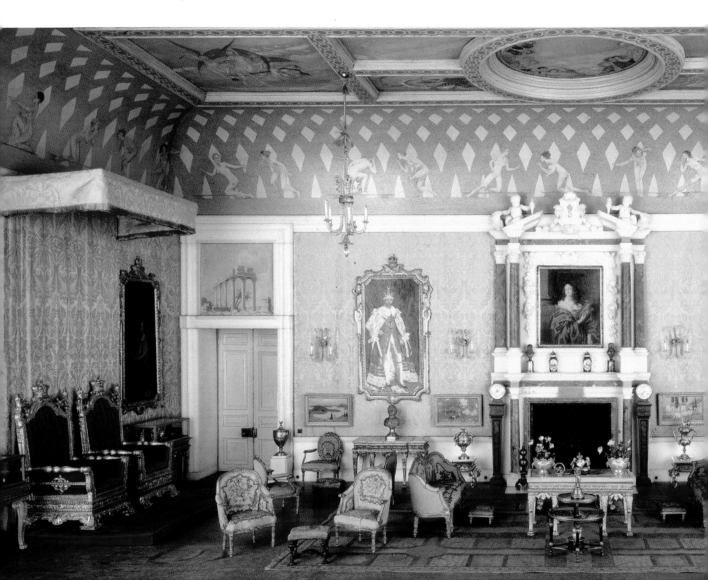

in *trompe-l'oeil* and rather twentieth-century looking nymphs. The doorcases, dado and cornice are all of white marble, while the walls are hung with 'Pavia pattern' rose-coloured silk damask, woven to a minuscule scale by the Gainsborough Weaving Co. of Sudbury in Suffolk. It has now faded to a golden tone.

The furnishing of the Saloon is interesting as it shows the 1920s approach to the arrangement of a drawing room, with 'Georgian' sofas, chairs, and tables grouped in the centre of the room rather than ranged round the walls as they would have been in the eighteenth century. The silver thrones under canopies are jokey exceptions. They were designed by Lutyens and are very similar to the thrones he provided for the Viceroy's House in Delhi. The principal seat furniture

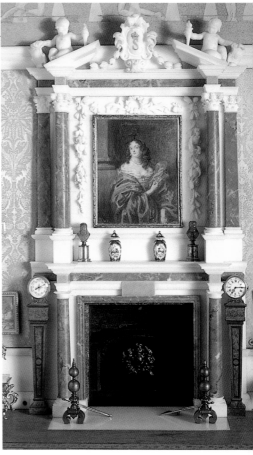

The Indian marble chimneypiece is inspired by the designs of Inigo Jones and frames a portrait of the Electress Sophia of Hanover, mother of George I and ancestress of the present royal dynasty.

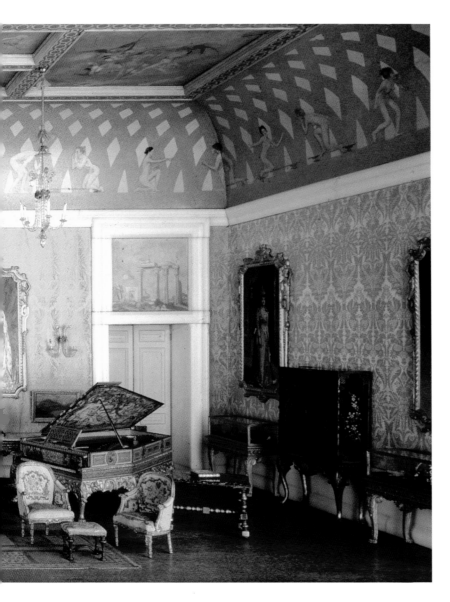

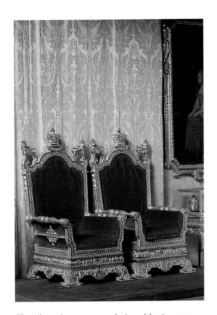

The silver thrones were designed by Lutyens and are similar to those which he supplied for the Viceroy's House in New Delhi, the new capital of India, which he was working on at the time.

comprises two gilt sofas and various armchairs with needlework covers and is copied from the Chippendale furniture at Harewood House in Yorkshire. (King George V's and Queen Mary's eldest daughter, The Princess Royal, married the 6th Earl of Harewood in 1922). The grand piano, based by Lutyens on his design for one made for the Paris Exhibition in 1900, was made by Broadwood & Sons, while its case was painted by T. M. Rooke

On either side of the fireplace are a pair of gilt console tables with elephant's tooth tops. The other furniture in the room includes a red and gold lacquer cabinet on a stand – a copy of one then at Londonderry House in Park Lane, commissioned and presented by the Marchioness of Londonderry. The central table, with its tiny *pietra dura* top is a genuine eighteenth-century piece, perhaps a sample or apprentice's model. The glass girandoles and the two chandeliers were made after eighteenth-century Irish models, while the carpet is a copy of a sixteenth-century Indian 'garden pattern' rug.

The paintings in the Saloon complement its stately architecture. Framed into the chimneypiece is a portrait of the Electress Sophia (1630–1714), mother of George I and ancestress of the Hanoverian dynasty. The overdoors show architectural capriccios of ruins, painted by Lady Patricia Ramsay, who was a granddaughter of Queen Victoria. The four small landscapes below the line are by Adrian Stokes. The principal display is of six full-length state portraits, 10 inches (25cm) high, in identical carved and gilt Lutyens-designed frames (made by Amédée Joubert & Sons), and paid for by Mrs Marshall Field of Chicago. They are of King George V and Queen Mary by Sir William Orpen; King Edward VII and Queen Alexandra by Sir John Lavery; and George III and Queen Charlotte by Harrington Mann, after those by Reynolds at the Royal Academy.

The central table of the Saloon has a genuine eighteenth-century *pietra dura* (hardstone) top. It may have been an apprentice's model.

THE ROYAL BEDROOMS

THE REMAINDER OF THE PRINCIPAL FLOOR is given over to the King's and Queen's apartments, each comprising three rooms: a wardrobe or dressing room, a bedroom and a private bathroom. Lavishly appointed down to the smallest details and the epitome of 1920s *haute luxe*, these are among the most remarkable rooms in the house. The Queen's Rooms occupy the south side of the main floor.

THE QUEEN'S APARTMENT

The Queen's Wardrobe

A door from the Saloon leads straight into the Queen's Wardrobe, which can also be reached from the secondary staircase. This small but monumental space has a vaulted ceiling with little saucer domes, like Wren's aisles in St Paul's Cathedral. In architectural terms it forms a pendant to the bathroom on the other side of the Queen's Bedroom. The ceiling was painted by Professor R. Anning Bell with the Five Senses, Four Winds and Four Seasons. Along the sides are fitted clothes' cupboards. There is a Chubb safe for jewels and a parasol of the type used by Queen Mary, made by Briggs. Above on the Mezzanine is the Luggage Room, where suitcases, hat boxes and travelling trunks are stored.

The Queen's Wardrobe, with saucer-vaulted ceiling, inspired by the aisles of Wren's St Paul's Cathedral.

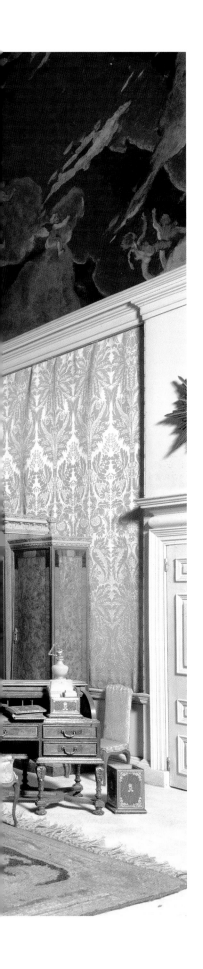

The Queen's Bedroom

This room is similar architecturally to the Saloon, with a high coved ceiling and two-tier chimneypiece of Inigo Jones inspiration, here of white marble and green jade. The walls are hung with silk damask which was originally blue but has now faded to a silvery grey. The tall 'Queen Anne' four-poster bed, with shaped and domed canopy and plumes of ostrich feathers at the four corners, was designed by Lutyens and inspired by the state beds at Hampton Court. The ceiling cove was painted by Glyn Philpot with a dramatic skyscape representing Night and Day, and its rectangular central panel is lined with cloudy looking-glass.

The portrait framed into the chimneypiece is of Queen' Mary's mother, the Duchess of Teck, and was painted by Frank Salisbury. The other portrait in the room is of Mary, Queen of Scots by Gerald Kelly. The furniture, in homage to Queen Mary, is redolent of her personal taste for 'antiques'. The carpet, a copy of an Aubusson, is 13.75 inches (35cm) by 16.5 inches (42cm), and was woven by the Stratford-on-Avon School of Weaving. The cream lacquer cabinet on a stand is derived from a rare James II original. The large amboyna veneered cupboard was copied from an example in the Lever Collection (formed by the industrialist 1st Viscount Leverhulme for public display in the museum of his model village at Port Sunlight, Cheshire), while the little walnut table at the foot of the bed is a copy of a late seventeenth-century example (a period then much admired) in the Devonshire Collection at Chatsworth. The gilt Garter Star-pattern clock and barometer over the doors are again original designs by Lutyens himself. Comfortable chairs, a daybed, a writing desk and a fully decked dressing-table with diamond-framed looking-glass complete the furnishings, while every surface is covered with small *objets d'art*: tiny carved hardstone animals, bonsai trees, and a blue enamel Cartier clock. The silver wall sconces, like those in the dining room, are modelled on those at Windsor, and there is a fine eighteenth-century pattern glass chandelier.

LEFT: The Queen's Bedroom is a delightful evocation of civilised twentieth-century luxury, with a tall four-poster bed similar to those at Hampton Court Palace. The dramatic night sky painted in the ceiling cove is by Glyn Philpot.

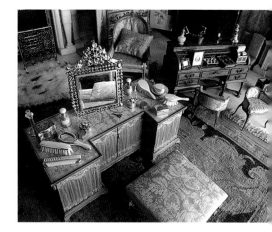

RIGHT: The dressing-table in the Queen's Bedroom, with diamond-framed looking-glass and turquoise enamel-backed brushes.

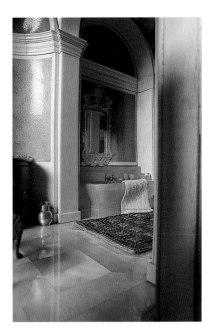

The floor of the Queen's Bathroom is of mother-of-pearl and the walls lined with ivory and green shagreen (dyed shark's skin), an exotic material favoured by the Georgians for small objects such as étui, and snuff-boxes, of the type collected by Queen Mary.

RIGHT: The King's Wardrobe. The vaulted ceiling was painted by William de Glehn. These small spaces are among the most memorable of Lutyens' interiors in the house.

The Queen's Bathroom

The Queen's Bathroom repeats the St Paul's Cathedral aisle format of the Wardrobe, with saucer domes and arches. It is astonishingly richly finished: the floor is of mother-of-pearl and the walls are lined with shagreen (dyed shark's skin) and ivory, while the bath and wash basin are of alabaster, with silver taps. The ceiling was painted by Maurice Greiffenhagen of the Glasgow School of Art with a seascape dotted with fish and mermaids. All is ready for use, with soft towels and a range of essences and soaps supplied by the firm of J. & E. Atkinson. Tiny drops of water come out of the taps, and Lutyens is known to have taken pleasure in explaining the plumbing to Queen Mary.

THE KING'S APARTMENT

The King's Apartment, like the Queen's, comprises a wardrobe/dressing room, bedroom and bathroom, to the same architectural format but with more sombre and masculine colouring and furnishing. The provision of separate bedrooms for husband and wife had been a feature of the planning of upper-class English houses since the eighteenth century, when it was first introduced as a French fashion. Lutyens usually adopted this arrangement in his house plans, for instance at the British Embassy in Washington, where it caused problems for the first residents, Lord Howard of Penrith and his wife, who found it inconvenient and uncosy.

The King's Wardrobe

The King's Wardrobe is lined with panelled cupboards, all painted white. By contrast, the vaulted ceiling was brightly decorated by William de Glehn. The light fitting, in mother-of-pearl and ivory, was designed by Lutyens and is a pair to that in the bathroom, while on the round table rests a little ceremonial Field Marshal's sword, made by Wilkinson.

The King's Bedroom

This room is particularly beautifully proportioned and visually satisfying, with its subdued decoration. The walls were painted by George Plank, to represent panels of Chinese wallpaper. Plank also painted the central rectangle of the ceiling with one of the best jokes in the house. It looks like a trellis pergola with flowers, but is in fact a musical stave with the first bars of the National Anthem picked out on it in blooms. The finely carved doorcase has a swan-necked pediment with a central cartouche. The chimneypiece with Ionic columns is of black, white and Siena marble. Above it hangs a portrait of Princess Mary, The

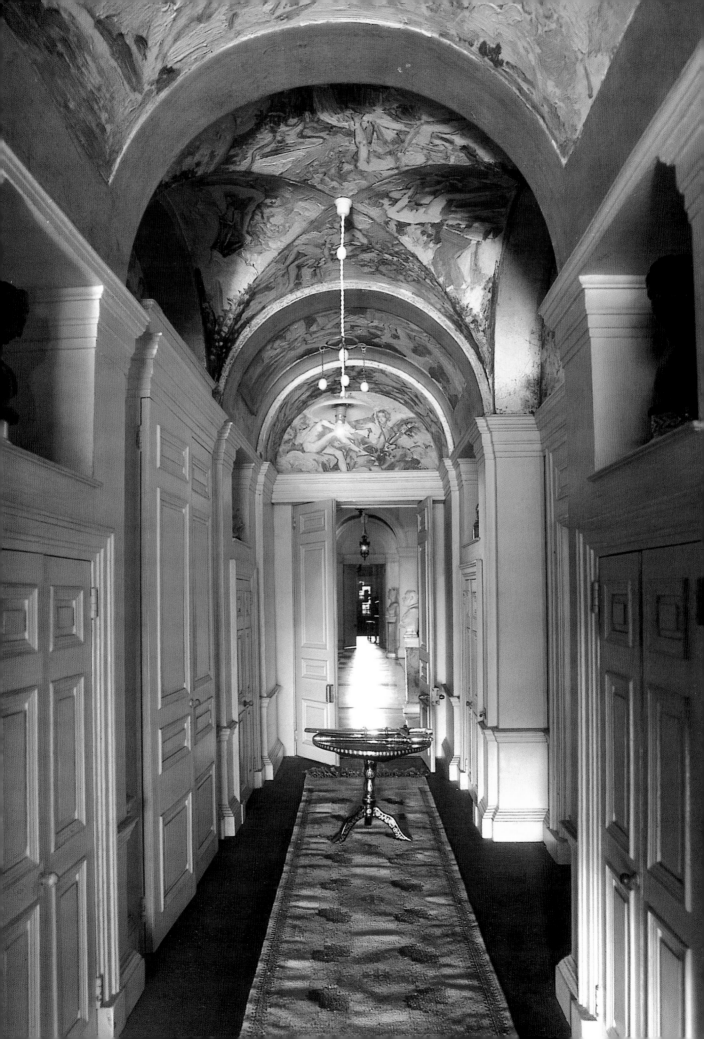

Princess Royal, by Ambrose McEvoy. The four-poster bed, designed by Lutyens, like that in the Queen's Bedroom, is also based on the Hampton Court state beds. It is hung with rose and gold silk damask and its headboard, embroidered with the royal arms, is the work of the Royal School of Needlework. It was given by Princess Christian, Princess Marie Louise's mother, who was the founder of the school. The silver chandelier, copied from one at Knole, was made by Elkington.

Other furniture in the room includes miniatures of late seventeenth- and eighteenth-century examples, mainly in walnut, including a pair of 'George I' chests of drawers, a pair of splat-back and a pair of 'Chippendale' chairs, as well as comfortable armchairs and a sofa upholstered in rose and gold damask. The carpet was worked in *petit point* embroidery.

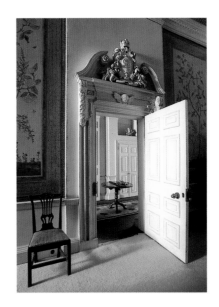

OPPOSITE: The King's Bedroom. The four-poster bed with ostrich plumes was again inspired by the state beds at Hampton Court. The panels of Chinese wallpaper were painted by George Plank. Over the chimneypiece is a portrait of King George V's daughter, The Princess Royal, by Ambrose McEvoy.

RIGHT: Doorway in the King's Bedroom, with swan-necked pediments, leading through to the King's Wardrobe.

BELOW: The ceiling of the King's Bedroom is one of the best jokes in the house. The painted trellis represents the opening bars of 'God Save The King'.

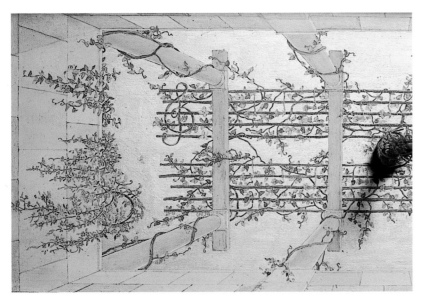

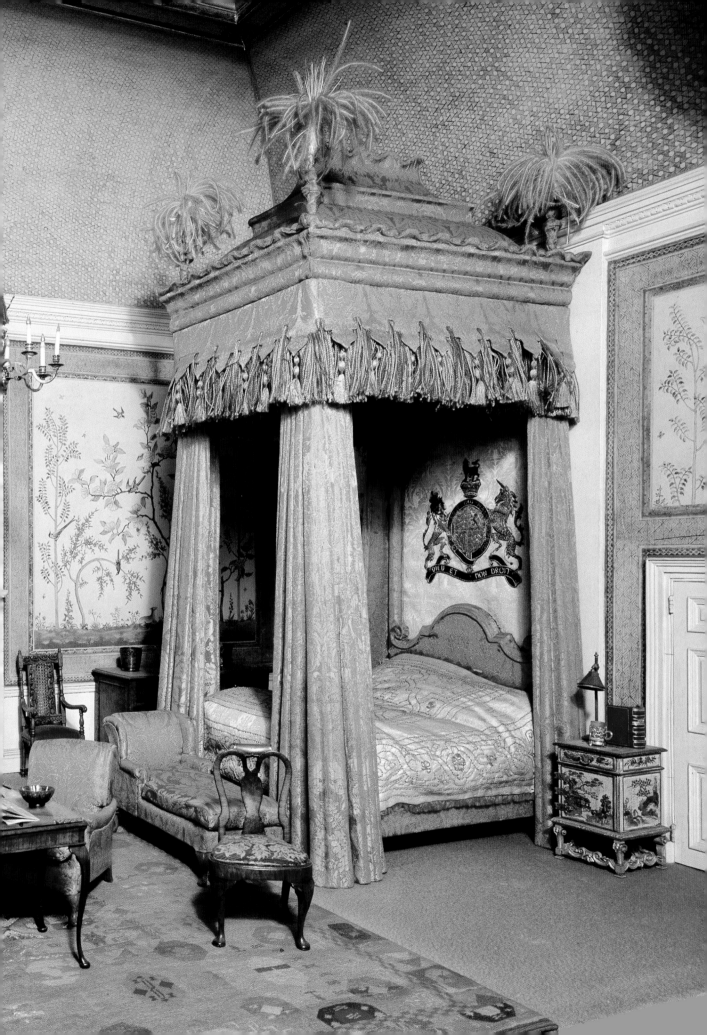

The King's Bathroom

The King's Bathroom has a vaulted ceiling, painted by Lawrence Irving with satyrs and signs of the Zodiac. On the walls are miniature *Punch* cartoons in red lacquer frames. The dado, bath and wash basin surrounds are all of green African verdite marble while the floor is of white marble. The equipment includes tiny toothbrushes made by Addis, using the finest hairs available, from inside the ear of a goat, as well as bottles of manly hairwash and rosewater.

The King's Bathroom, in green and white marble, with framed *Punch* cartoons on the walls.

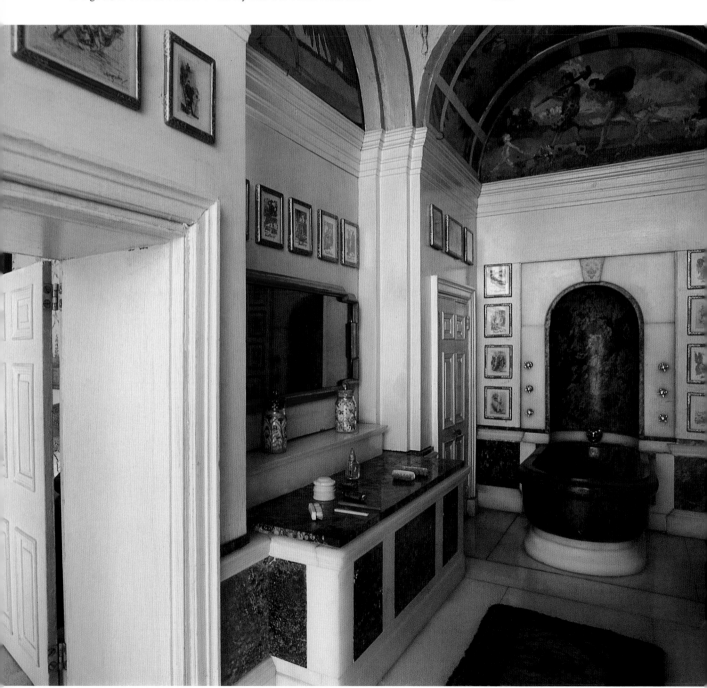

THE MEZZANINE AND TOP FLOOR

ON THE MEZZANINE LEVELS in the corners of the house are six servant's rooms. These all have fireplaces, and were comfortably furnished by Waring & Gillow. They are graded according to rank. The senior servants were provided with wooden beds with horsehair mattresses, while the juniors had iron beds with flock mattresses. All were provided with wash-stands, and the male servants have trouser-presses in their rooms.

The top floor of the house has two bathrooms and six principal rooms, (each with a corner chimneypiece), some for servants and some for the family. The latter, reached by the passenger lift in the north-west corner, comprise: The Princess Royal's Bedroom, the Queen's Sitting Room, the Night Nursery (all facing west) and the Day Nursery (facing south).

THE PRINCESS ROYAL'S BEDROOM

This is a simple white-painted room, but is charmingly furnished with a chest of drawers, wash-stand, and chairs decorated in late Georgian taste. A matching wardrobe, with neo-classical coloured arabesques on a cream ground, stands in

The Princess Royal's Bedroom. This small room on the upper floor has painted 'Georgian' furniture and a bed which is a copy of that designed by Lutyens for his own daughter.

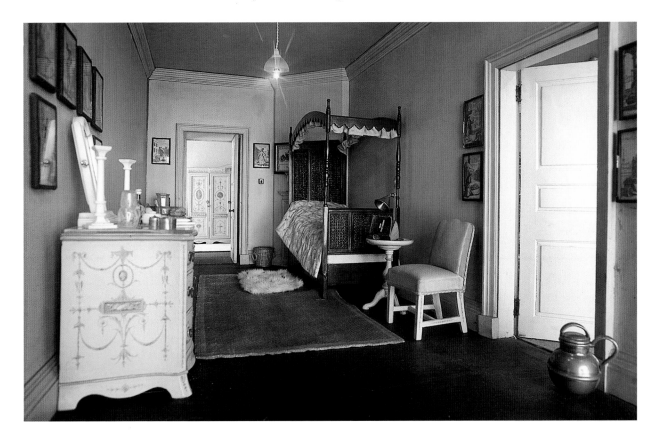

the lobby outside. The four-poster bed is 7 inches (17.8cm) high and is a copy of the bed Lutyens designed for his own daughter (which was in turn inspired by that in Vittore Carpaccio's painting *The Dream of St Ursula* of 1490–95). The set of twelve tiny framed prints showing 'The Cries of London' are antiques, presented to the house by the Anglo-American collector Edward Knoblock. The pink Cauldron Pottery wash-stand set is similar to other sets in the servants' and children's rooms.

THE QUEEN'S SITTING ROOM

This room is the most personal tribute in the house to Queen Mary, and is a record of some of her particular interests and enthusiasms, including Chinoiserie decoration, oriental hardstone carvings and needlework. The latter is indicated by an unfinished floral piece draped over the back of a chair. The walls are hung with yellow silk, painted with water lilies by the famous illustrator Edmund Dulac. The furniture is painted cream, lacquered in the Chinese taste, while the set of chairs simulates bamboo in the Georgian manner. The two glass display cabinets are scale models of Queen Mary's own at Buckingham Palace, and contain a collection of tiny jade and amber carvings of animals, including a water buffalo, a goat and a lion. There are also eight Egyptian amulets and a Siamese tobacco jar, while the rug is a copy of a Chinese eighteenth-century design.

The Queen's Sitting Room was intended to represent Queen Mary's personal tastes, including her enthusiasms for needlework, chinoiserie decoration and collecting small objects such as oriental hardstone carvings.

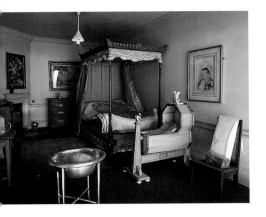

THE NIGHT NURSERY

Next door, the Night Nursery contains a 'Chippendale' four-poster bed for Nanny and a cot for the Prince of Wales. The latter was designed by Lutyens in an impressively monumental key, and was presented by the banker F. A. Koenig, for whom the architect was working at Tyringham in Buckinghamshire. It is made of ivory and applewood with a silver trim. At the foot an obelisk supports a praying angel, and at the head an octagonal canopy is topped off with a coronet and the Prince of Wales' feathers. The other furniture is no-nonsense simple oak. Nanny's conservative tastes are hinted at by a portrait of Queen Victoria (by R. A. Pinks), a colourful flower piece (by F. M. Bennet) over the fireplace, and *Bubbles* (after Millais) by Alfred Hemming.

This room and its adjoining bathroom are equipped with a nostalgic array of baby products: Allenburgs Rusks, chocolate, powdered milk, and Vaseline; as well as a glass feeding bottle 1 inch (2.54cm) long, baby soaps and a packet of 'Bromo'.

TOP: The Night Nursery with a 'Chippendale' four-poster for Nanny and an impressive cot for the Prince of Wales, designed by Lutyens and made of applewood, ivory and silver.

ABOVE: The Nursery Bathroom is a much simpler affair than the royal bathrooms downstairs. The brightly painted scarlet chair is typical of Lutyens' enthusiasm for strong colours.

BELOW: The gramophone in the Nursery with 'His Master's Voice' records of the National Anthem, 'Rule Britannia' and 'Home Sweet Home'.

THE DAY NURSERY

The Day Nursery is a display piece of the classic age of English toys, with its train set, lead soldiers, model theatre (with a set for *Peter Pan*), hobby horse, dolls, Winsor & Newton paint-box, chic wooden Pomona toys and an upright piano. The walls are colourfully decorated with scenes of nursery tales, again painted by Edmund Dulac.

A then modern feature is the wind-up gramophone with a set of 'His Master's Voice' records of the National Anthem, 'Rule Britannia' and 'Home Sweet Home'. The rather vulgar mahogany case of this luxury item contrasts with the tasteful rustic quality of the other furniture, including an oval gateleg table and Windsor chairs. In the lobby outside, glazed corner cupboards contain a nursery service by Wedgwood (marked with an N, to differentiate it from the kitchen set downstairs, marked K), and suitable provisions such as cocoa, Huntley & Palmer biscuits, Nestlé's condensed milk and Tiptree jams.

ABOVE: Tins of Huntley & Palmer and McVitie & Price biscuits, and Fry's cocoa were among the provisions selected by Lady Jekyll.

BELOW: The Day Nursery with its wonderful array of children's toys, including a train set, model theatre and tiny car.

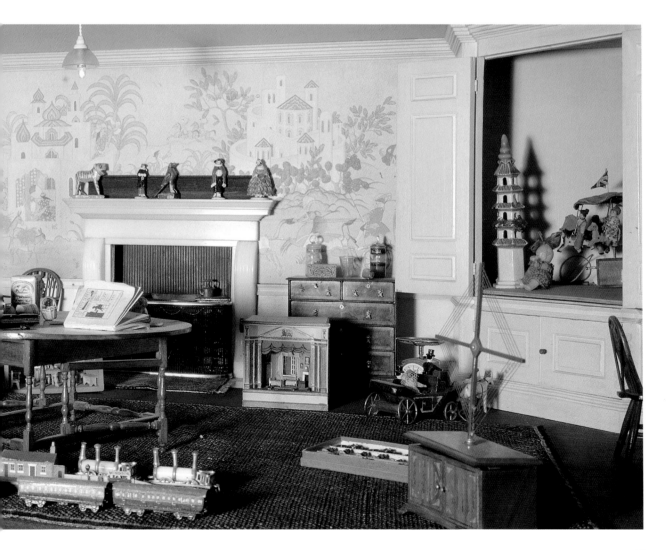

The east side of the top floor, served by the back stairs (with Chinese Chippendale-style banisters painted royal blue), contains the Housekeeper's Bedroom, Linen Room and the maids' bathroom. (The menservants' bathroom is at the mezzanine level, down below.) These rooms are an accurate record of early twentieth-century domestic arrangements now, of course, largely superseded by the labour-saving inventions of the past century.

THE LINEN ROOM

This large, handsome room, with an early Georgian-style marble fireplace, has six large panelled oak cupboards fitted round the walls. In the centre is a Lutyens table, similar to that in the kitchen, and Windsor chairs. A wicker laundry basket can be spied under the table, ready to take used items to a commercial laundry. 'Modern' inventions are present in the form of an early electric iron and a classic Singer treadle sewing-machine. The cupboards contain a complete collection of household linen: tablecloths and napkins, towels and drying cloths, sheets and pillow-cases. Most of the linen is painstakingly monogrammed *GRI* with a crown.

THE HOUSEKEEPER'S BEDROOM

Appropriately, this room has crisp 'modern' furniture of unstained hollywood by Waring & Gillow, and pretty china on the wash-stand.

THE HOUSEMAID'S CLOSET

These top-floor service rooms are completed by the Housemaid's Closet, which contains two sinks, copper hot-water cans and an array of cleaning materials such as Lux soap and Vim, as well as mops and brushes. Another modern invention can be spied, in the form of a classic Hoover vacuum-cleaner. Even a utilitarian space like this was handsomely treated by Lutyens, and the splash-back above the sinks is covered with miniature replicas of blue-and-white Dutch tiles, of which he was very fond.

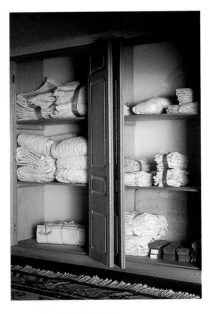

TOP & ABOVE: The linen in the Linen Room was all woven in Belfast and comprises complete sets of bed linen and table linen – painstakingly embroidered with the royal cypher *GRI*.

BELOW: The Singer Sewing Machine in the Linen Room. This American invention became a standard feature of many homes between the wars.

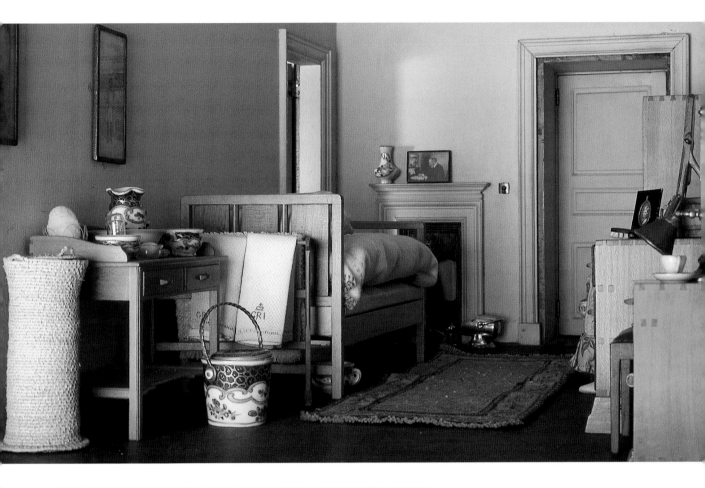

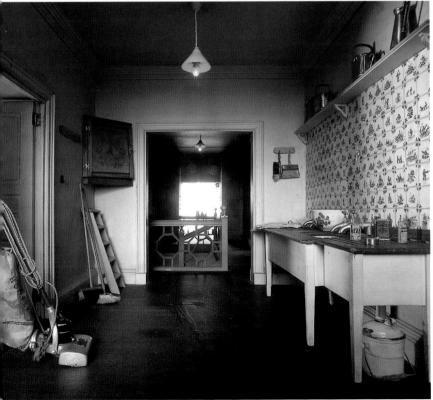

ABOVE: The Housekeeper's Bedroom is typical of the rooms provided for the upper servants, with neat modern furniture from Waring & Gillow and colourful wash-stand sets from the Cauldron Pottery.

LEFT: The Housemaid's Closet. The splashback to the sinks, with hand-painted Dutch tiles, is a characteristic Lutyens touch; he often used such tiles in his houses. The electric Hoover vacuum-cleaner was then a very modern invention.

ABOVE: Cellar equipment for decanting wine, including a tiny corkscrew.

RIGHT: The Wine Cellar was stocked by Berry Bros. of St James's Street, using specially made miniature bottles.

ABOVE: The cellar book, prepared by Francis Berry, with hand-written entries for all the cellar contents.

OPPOSITE: As well as wine, the cellar contains cases and casks of Bass beer, including Pale Ale and King's Ale.

BELOW: Bottle of Premier Cru Chateau Margaux 1899, two dozen of which are stored in the cellar. The real cork indicates the size.

THE WINE CELLAR

THE WINE CELLAR is a large, groin-vaulted, space at basement level and was stocked by Francis Berry of Berry Bros., the St James's wine merchants (still happily flourishing), with a splendid selection of vintages. The tiny bottles were blown by the Whitefriars Glass Co., and authentic labels reproduced by micro-photography. There is also bottled and barrelled beer from Bass at Burton-on-Trent. The cellar is replete with all the necessary equipment, including corkscrew, funnel and a cellar book, which lists the contents opposite.

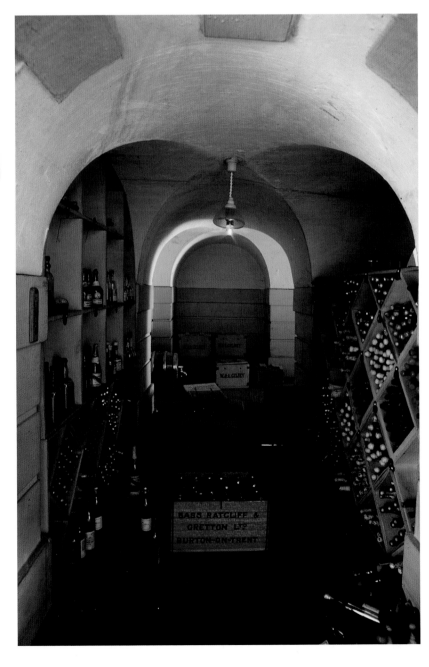

Qty.	Name	Vintage
Doz.	CHAMPAGNE	
5	Veuve Clicquot	1906
5	Pommery & Greno	1915
5	Louis Roederer	1911
5	G. H. Mumm & Co.	1911
2	G. H. Mumm & Co.	1911 (magnums)
	CLARET	
2	Ch.-Lafite, Grand Vin	1875
2	Ch. Haut-Brion	1888
2	Ch. Margaux	1899
2	Ch. Le Prieuré	1918
	PORT	
2	Cockburn Smithes & Co	1878
2	Taylor Fladgate	1896
2	Warre	1900
2	Fonseca	1908
2	Dow	1912 (magnums)
2	Royal Tawny	
	SHERRY	
2	Amoroso Pale Golden	
2	Oloroso Puro	1872
	MADEIRA	
2	Finest Bual	1820
	WHITE BURGUNDY	
2	Montrachet	1889
2	Graves-Supérieur	
2	Chablis-Moutonne	1904
	SAUTERNES	
2	Ch. Yquem	1874

Qty.	Name	Vintage
	BURGUNDY	
2	Romanée	1904
	HOCK	
2	Rudesheimer	
	BRANDY	
2	Grande Fine Champagne	1854
1	Hennessy's ***	
	GIN	
2	Dry London Gin	
	RUM	
1	Fine Old Jamaica Rum	
	SCOTCH WHISKY	
¼ cask	G. & J. G. Smith's Glenlivet (28 gals)	1910
	IRISH WHISKEY	
¼ cask	J. Jameson & Sons, Dublin	1907
Doz.	FRENCH VERMOUTH	
2	Noilly Prat. Litres	
	ITALIAN VERMOUTH	
2	Martini Rossi	

Qty.	Name
	LIQUEURS
1	Pères Chartreux Yellow. Litres
1	Benedictine, D.O.M.
1	Riga Kummel, Fleur de Cumin
1	Sloe Gin
1	Cherry Brandy
1	Apricot Liqueur
1	Crême de Menthe, Cusenier (all the above bottled by Berry Bros & Co.)
1	Gilbey's Champagne Brandy (in one case)
1	Gilbey's Whisky (in one case)
2	Gilbey's Tawny Port (in two cases)
1	Gilbey's Château Laudenne (in one case)
1	Gilbey's Vintage Claret
4	Bass Pale Ale (in two two-dozen cases)
8	Bass Pale Ale
4	Bass King's Ale (in two two-dozen cases)
1	Bass King's Ale
2 casks	Bass Pale Ale
2 cases	Gordon and Tanqueray's London Gin
1	Johnnie Walker Whisky (1 dozen cases)

THE GARAGE

THE GARAGE, in its fall-front drawer, occupies the basement at the west end of the house. It contains six cars, all painted in the black and maroon royal livery. They represent the great British motor manufacturing companies of the 1920s: Daimler, Rolls-Royce, Sunbeam, Vauxhall and Lanchester. In addition there is a Rudge motorcycle and a Rudge bicycle, a fire-engine, petrol pumps and cans.

BELOW: The Garage, with a Rudge motorcycle and sidecar parked by the petrol pump.

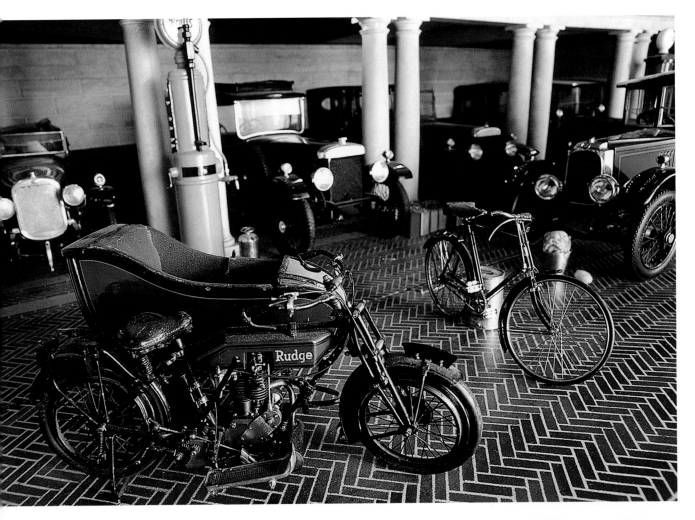

RIGHT: Detail of a tiny dashboard and steering wheel in one of the dolls' house cars.

THE GARDEN

THE GARDEN LIES ON THE EAST SIDE of the house below the Dining Room and Saloon windows, and folds up ingeniously to fit into one of the basement drawers. It was designed by Gertrude Jekyll, doyenne of English gardeners, who collaborated with Lutyens on the settings for so many of his houses. There are lawns (of green velvet), dwarf hedges of box (painted rubber) and flower beds filled with blue and purple irises, standard roses, lilies, carnations, sweet peas,

The dolls' house mowing machine for the immaculate lawn. A miniature garden pest is visible crawling along the edging to the flower bed.

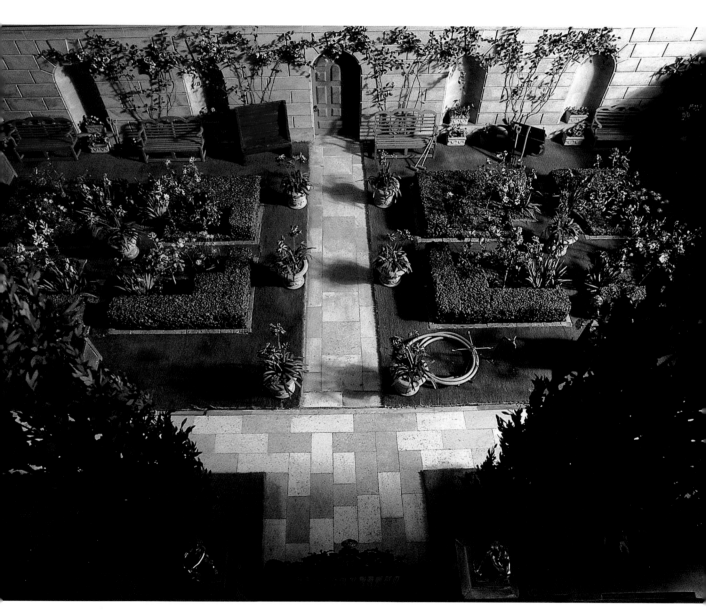

Box-edged beds and flower pots brimming with roses, irises and lilies. The garden benches designed by Lutyens are still in production today. The garden implements include a little wheelbarrow and a hosepipe for watering the flowers.

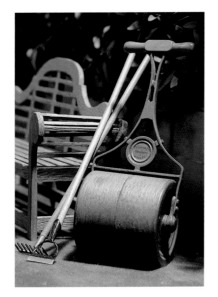

poppies, marigolds, mallows and gentians, all modelled in painted metal by Miss Beatrice Hindley. There are also agapanthus in Italian terracotta pots, and hydrangeas and rhododendrons in wooden tubs. *Magnolia grandiflora* is trained against the side walls and climbing roses range over the basement walls of the house. Six cypress trees (made out of real twigs from Dartmoor) stand sentinel along the front. Lutyens features include miniatures of his classic garden bench (which is still in production) and the wrought-iron entrance gates. A tiny birds' nest with eggs, a snail and even butterflies can be found amidst the planting – miniature and fitting grace notes to the painstaking detail and gentle humour found throughout the dolls' house as a whole.

The garden roller, hoe and rake, with one of Lutyens' classic garden benches in the background.

RIGHT AND BELOW: Details of irises and roses which were painstakingly made in painted metal by Miss Beatrice Hindley, a friend of Gertrude Jekyll's. Miss Hindley also made the flower arrangements and pot plants inside the house.